A Different Country

I listen to these songs
from a city studio
They belong to a different country
to a barer sky
to a district of heather and stone

Iain Crichton Smith, *Gaelic Songs*

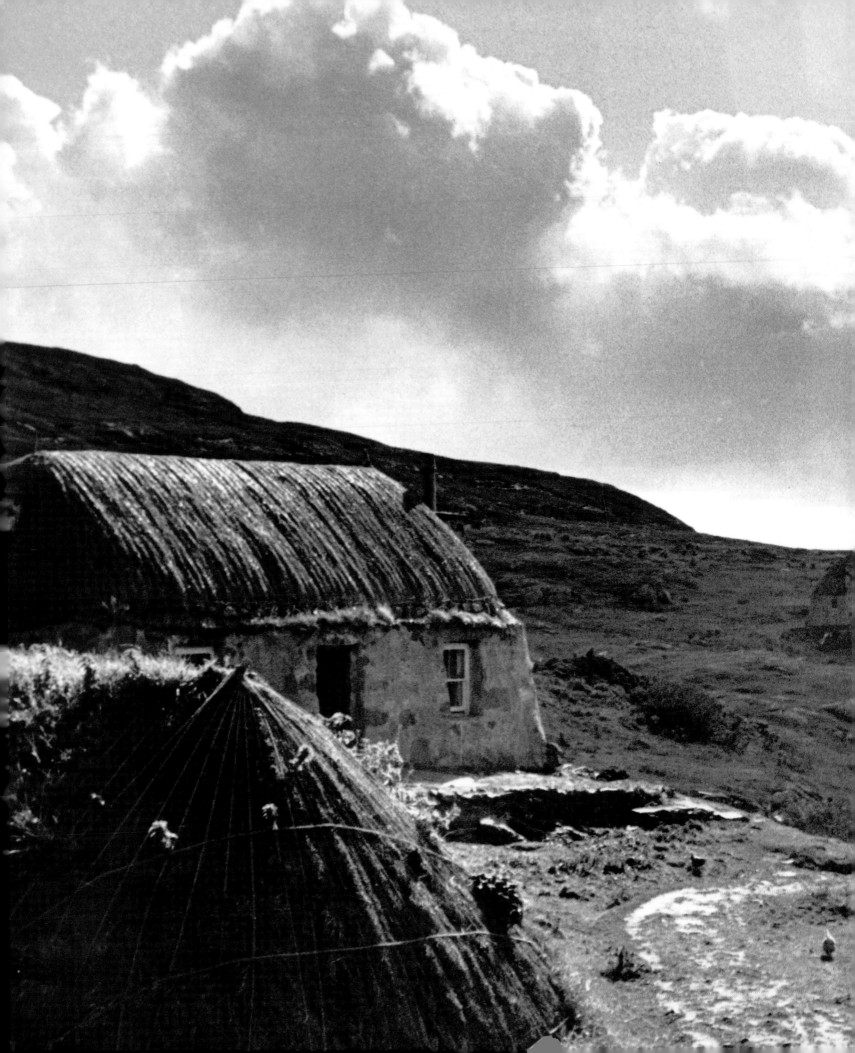

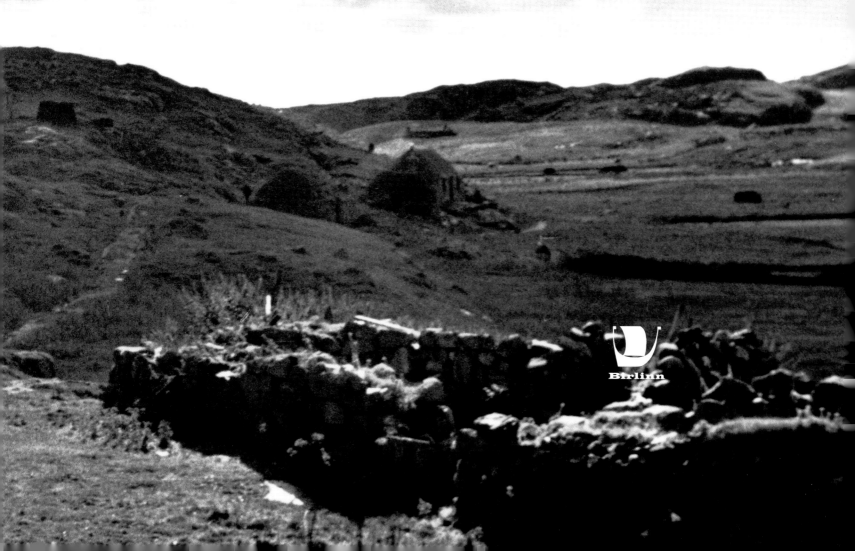

A Different
Country

The Photographs of
WERNER KISSLING

MICHAEL RUSSELL

First published in Great Britain in 2002 by
Birlinn Ltd, West Newington House
10 Newington Road, Edinburgh EH9 1QS

www.birlinn.co.uk

ISBN 1 84158 245 X (cased)
 1 84158 261 1 (paperback)

The publisher gratefully acknowledges financial assistance
from the Russell Trust

The publisher acknowledges subsidy from

Scottish
Arts Council

towards the publication of this volume

British Library Cataloguing-in-Publication Data
A catalogue record for this book is available
on request from the British Library

Design and typesetting by Antony Gray
Printed and bound in Spain by Bookprint, S.L., Barcelona

Contents

List of Illustrations

Acknowledgements

The idea of publishing more of the photographs of Werner Kissling was first proposed by Hugh Andrew of Birlinn, one of the most energetic and entrepreneurial of Scotland's publishers, but it has taken more than two years to bring the idea to fruition. Hugh was fortunately enthusiastic about my idea of including not just a brief updated biography – for some interesting new information has come to hand in the five years since the publication of *A Poem of Remote Lives*, an illustrated biography of Kissling based on a BBC documentary first broadcast in January 1996 – but also a brief survey of images of the Hebrides and some thoughts on the enduring problems of rural Scotland, well known to Kissling himself, but now even more severe as the centuries have turned. He was also relaxed about including in the collection some of the images Kissling took furth of the Western Isles, as these formed a large part of his later output though they still reflect his life-long interest in people and the places in which they lived and worked.

I am therefore grateful to Hugh and also to Neville Moir, who managed the project, for all their support and assistance in bringing this book to fruition, and for their patience in dealing with an author who is also a working politician with all that means in terms of diaries and unexpected commitments. Thanks are also due to the Scottish Arts Council and the Russell Trust for their financial help to the publisher.

An early decision to use as the primary source for reproduction the excellent collection of Kissling photographs held by the School of Scottish Studies would not have been possible without the permission of Edinburgh University and the support of the director of archives at the school, Dr Margaret MacKay. The school's archivist in charge of the photographic collection, Ian MacKenzie, was also crucial to the undertaking, and I am grateful for the time and effort he devoted to supporting my hours in his library and in providing background information on the pictures. David Lockwood, Kissling's executor, continued to be helpful and interested, and devoted time to helping to source items held by Dumfries Museum as well as the school. Sara Stevenson, the curator of the great photographic collection at the Scottish National Portrait Gallery was unstinting in her advice, as was the writer Ian

Mitchell, who was inspirational in conversation and gave very wise advice with regard to a late draft of the final essay, 'The Human Landscape'. I am only sorry that my planned excursion on his boat to Norway for a week during the summer of 2002 – to look at good practice in allowing human beings to remain on their own landscape – became impossible for a variety of personal and work reasons.

My immediate colleagues in the Scottish Parliament tolerated my enthusiasms and my absences with equanimity and bore the brunt of re-arranging commitments at short notice to allow writing or research time. Many thanks to Irene McGugan MSP, Dr Alasdair Allan, Joan Sturgeon, Eilidh Bateman, Robert Clark and Andrew Watson. As usual my hours at the word processor or poring over photocopies of pictures were largely carved out of the little time I get to be at home in Argyll, so apologies once more to Cathleen and Cailean for their tolerance and for their interest in the life and exploits of Werner Kissling, whom they never invited in, but with whom they have lived at closer quarters than they ever expected, and for more years than they care to remember.

Since my late teens I have been inspired by the work of Iain Crichton Smith, and I was privileged to film him for another BBC documentary in 1992. It was to his words that I went for a title for this book and then surprisingly found myself back at his writing for a conclusion to the final essay. His understanding of the knife edges on which Scotland stands – between its Gaelic and English, island and mainland, and rural and urban existences – and the way in which this edge is walked at personal cost by so many has greatly informed my own concern about these problems. His wisdom, insight and wit are greatly missed.

Feorlean, Argyll
September 2002

ONE

*Vision of a
Different Country*

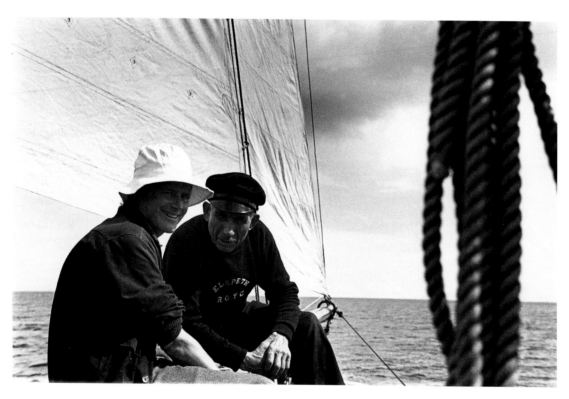

Werner Kissling on the *Elspeth* with the skipper (The Skyeman) taken in 1934 – this is my favourite picture of him.

Werner Kissling:
An Outline Biography

Writing a biography of someone you have never met, and someone who you will never meet because they are dead, establishes the strangest type of relationship. Working in the Western Isles in the late 1970s, I came across a story of a German who had sailed to the island of Eriskay in the 1930s, along with a 35mm film camera and made the first ever moving picture to use spoken Gaelic. As I was making pictures in the same sorts of places myself at that time and using Gaelic in them – though my medium was half-inch video rather than massive reels of celluloid – the story intrigued me.

A copy of Werner Kissling's single film – *A Poem of Remote Lives* – had lain in the archives of the School of Scottish Studies at Edinburgh University until the late 1970s. At that time the school disposed of much of its collection of film and gave it to the Scottish Film Archive. The archive – in the person of its enthusiastic archivist Janet MacBain – arranged a number of showings of archive film of the Western Isles in the Western Isles under the aegis of the media development project I was running, and it was at one of these showings that Kissling's film had its first screening in the place where it was made since the 1950s, when, I subsequently discovered, Kissling himself would show it on summer evenings during his annual visits.

Janet knew a little about Kissling, including the intriguing fact that he was still alive, although now well over eighty and living in Dumfries, where he had recently held an exhibition of his photographs. He had been friendly with a number of people in South Uist and Eriskay and a few remembered him as a slightly sinister though very affable visitor.

In the early 1990s I was trying to make a living as an independent television producer and director, specialising mostly in Gaelic production. I took the idea of a television documentary about Kissling to the newly formed Gaelic Television Committee, only to have it rejected, as most ideas are on their first outing. I re-submitted it during the summer of 1994, after receiving research and development funding from the CTG, but in November of that year I accepted an offer to become Chief Executive of the Scottish National Party and prepared to put my television career on

ice, only to be offered, out of the blue, the opportunity to make the Kissling documentary for BBC Television.

As production got under way, with Ishbel MacIver undertaking the role of director whilst I tried to juggle production duties with politics, a chance contact through a friend with the publisher Neil Wilson resulted in another opportunity: the chance to write Kissling's biography and publish some of his photographs. Never one to say that I was too busy, I jumped at it.

The documentary[1] was broadcast on 11 January 1996, but the book[2] did not appear until the autumn of 1997 – an election and a referendum being more important priorities. Kissling himself had died in 1988 in the Moorfields Nursing Home in Dumfries, but his friends – led by his executor, the curator of Dumfries Museum, David Lockwood – had raised enough money to erect a memorial headstone to a man described on that black marble as 'Soldier, Diplomat, Scholar and Gentleman'. Those friends were generous with their time and effort in helping the documentary (much of which was filmed in Dumfries and Eriskay), and the book and many of the photographs were sourced from the collection in Dumfries Museum and from the suitcase of personal effects which Kissling had left to David Lockwood.

But there was more that came to hand as research proceeded. In particular the collection of Kissling photographs in the School of Scottish Studies was more extensive than a first look had indicated. Kissling had contributed items to the school during the 1950s and 1960s, at a time when he needed money, but he had included among the items much that he had taken earlier in Eriskay and South Uist. He had also placed in the collection a range of detailed studies of traditional crafts taken in Dumfries and Galloway, along with some reasonably comprehensive notes on at least some of the pictures. The fact that his work had been seen and studied by others was obvious, not least in the 'sub Kissling' genre of some later Scottish ethnological photographers.

The biography included photographs from Kissling's life, a detailed frame-by-frame analysis of his only film and some thirty-five full-page reproductions of pictures taken in the Western Isles and drawn mostly from the Dumfries collection.

But the balance of this book is very different, with an emphasis on his photographic achievements drawn largely from that under-utilised archive in the School of Scottish Studies, and with merely a brief reprise of his biography, including some additional information and comment that has come to light in the five years since that book was published, some reflections on images of the Hebrides and, finally, some thoughts concerning the relationship of people to landscape – a debate of huge importance in twenty-first-century Scotland and one which is central to Kissling's

1 *Kissling: Duin Iom' Fhillte (Kissling: The Enigma)*, Eala Bhan Ltd for BBC/CCG
2 *A Poem of Remote Lives: The Enigma of Werner Kissling*, Neil Wilson Publishing

work. The first book was a story illustrated by photographs. This one is photographs illustrated by some stories.

Let us start with the basic facts of Kissling's life which – though as an endless fantasist he embroidered them often – are easy enough to establish. Werner Friedrich Theodor Kissling was born on 11 April 1895 in the family home of Heizendorf near Breslau in Silesia, the second of the three sons of Georg and Johanna Kissling. His father was the grandson of the founder of a brewing dynasty which had generated considerable wealth, and Heizendorf was a substantial eighteenth-century castle which was surrounded not just by a lake but also by large family estates. He attended school in Breslau and Leobschutz and left school in June 1914, only weeks before the start of the First World War.

In August 1914 Kissling joined one of the élite German regiments, the Prussian Guard, but, unusually, left the regiment less than a year later and transferred to the German Navy, where he saw out the war. He then studied at universities in Berlin, Königsberg and Paris before entering the Consular School in Vienna, and subsequently worked in the diplomatic service, accepting postings in Riga, Geneva (including an attachment to the German delegation to the League of Nations), Madrid, Budapest and London.

He resigned from the post of Second Secretary at the German Legation in London in 1931 and pursued amateur studies in ethnology for the rest of his life, having become a Fellow of the Royal Geographical Society in 1930 and of the Anthropological Institute in 1931. He was interned in the Tower of London on the outbreak of the Second World War and subsequently on the Isle of Man, being released from internment in 1942 and allowed to return to his studies in Cambridge.

He was owner and proprietor of the Kings Arms Hotel in Melrose for over a decade, but suffered catastrophic financial losses as a result of this venture. He was subsequently Honorary Assistant at Dumfries Museum from 1969 to 1988.

Kissling contributed many thousands of photographs, mostly of ethnographic interest and featuring crafts and traditional activities, to a number of archives, and collected artefacts for Dumfries Museum. He contributed articles and photographs to a range of journals, but his most important piece of writing was a single monograph on the Hebridean Black House, which was published during the Second World War.

He was unmarried and had no children, but was survived by a nephew in Germany who had very little contact with him in the last thirty years of his life.

All the above can be verified from external sources. But when Werner Kissling himself told his story, he told it in different ways to different people. For example, in a letter to an enquirer in 1948 he claimed to have spent the First World War 'in the German cavalry', which was only very partially true. There was no truth at all in his frequently told story of his brush with the Nazis in 1933 when, he alleged, Hitler had personally told him to return to Germany from the London legation ('Your regiment

needs you'), and that he had only escaped from the Gestapo by means of a struggle which culminated in his running from the embassy building to a waiting car and being driven away by friends. Yet he and his family did have strong anti-Nazi credentials and his brother, Georg Conrad, was one of those who participated in the 'Colonels' Plot' against Hitler in July 1944. Indeed he was so bound up in the conspiracy that he shot himself rather than be arrested, interrogated and executed. Georg Conrad's involvement was enough to lead to the confiscation of the family property.

Although the story of Werner Kissling's flight from Hitler was false, he certainly acted, whilst a young trainee, as an assistant to the then Chancellor, Gustav Stresemann. As that period of work coincided with the Beer Hall Putsch in 1922, his account of meeting Nazi representatives, and finding them 'boorish and a load of ignorant shits', as he put it, may well be true.

Kissling's official record, however, shows quite clearly that he left the diplomatic service two years before Hitler came to power, and that he resigned voluntarily in order to pursue his ethnological studies. By this time he was a wealthy man, having inherited a sizeable fortune in present-day terms from his father. This was split between himself and his elder brother, Georg Conrad, as his younger brother, Gunther, had been killed on the Russian front in early 1915.

Georg Conrad continued to run the family businesses, chafing at the ability of Werner to spend all the money that was earned. Werner found no difficulty in that task, buying the best of everything, including shoes from Lobbs in London. He travelled extensively, and in 1938 was authorised to act on behalf of the Archaeological and Ethnographic Museum in Cambridge, as a letter describing him as both a research student and as the Librarian of the Lantern Slide Collection proves. At that time he went to New Zealand, having previously been in America, and it was on his return from New Zealand that he was interned in the Tower of London.

His photographic skill as a recorder of ethnographic information was by this stage considerable, having been honed by an active involvement in photography that dated from at least 1919 (there are extant photographs taken by him during the Iron Guard uprising in Riga) and fostered by the active involvement of his mother in photography during the many overseas trips she took when Werner was a child. One of those trips was to the Western Isles of Scotland, and he kept the postcard she sent him from there for the rest of his life.

Kissling's known anti-Hitler views and his strongly pro-British sentiments were enough for him to be transferred from the Tower to the Isle of Man, even without the intervention of friends who lobbied Lord Birkenhead. He quickly became a welfare officer in the internment camp – a position given only to those who were trusted – and was released before the war ended. But he was not allowed to travel into restricted areas, one of which was the Western Isles.

We do not know the date of Werner Kissling's first visit to the Western Isles, but we do know why it was made. His ethnographic studies had led him to a particular

interest in the form of domestic architecture known as the Hebridean black house, and the best place to study this was in the Outer Hebrides, where many such dwellings were still inhabited and where even more existed in a semi-ruinous state.

It is probable that he made an initial trip to the island of Eriskay in 1932 or 1933. Eriskay was an obvious choice for him as it was not only more remote than other islands, but it was also a place that maintained a strong indigenous culture. The Irish Folklore Commission had collected material there, and the work of Fr Allan MacDonald, the parish priest of Eriskay from 1884 to 1905, on songs and folklore was well known in ethnographic circles, as was less authentic material, such as the 'Eriskay Love Lilt' that had sprung from the pen of Mrs Kennedy Fraser.

Sometime after his first visit Kissling began to plan a film to complement his studies. This modest ambition may have been fanned into something more significant by the activities of Robert Flaherty, the Irish–American film-maker who spent a year on a small island off the Irish coast making his dramatised documentary *Man of Aran*, which was premièred with considerable hype and showmanship in London in April 1934, just as Kissling was finishing preparations for another trip to Eriskay. Kissling himself later confided to a friend that he had been inspired by the film. His visit to Eriskay in 1934 was thus envisaged as the chance to make a first essay or sketch for a much more complex film project which would document traditional life in the Western Isles.

Significantly that sketch was to be accompanied by a soundtrack, for just as *Man of Aran* had motivated him artistically, it also awoke him to some new technological developments – one of which was the use of sound with moving pictures. That innovation had been introduced while Flaherty was filming on Aran, and sound had been added to his film afterwards.

 Kissling almost undoubtedly used some form of sound recording on Eriskay, but whether any of that material made it to the finished soundtrack is a matter of debate. Bob Dickson, a Scottish exile working in film restoration in the USA, who has generously contributed financially to the costs of a restored print of the film, suggests that none of the sound that can be heard was actually recorded on location but was all added later.

We know that Werner Kissling spent most of the summer on Eriskay in 1934, living part of the time on the yacht which he had leased in Gourock (the *Elspeth*) and part of the time in a rented house belonging to one Ronald MacInnes. It is possible to estimate the time he spent on the island from the internal evidence of the film and the photographs he took, and it is likely he arrived in Eriskay at some stage in the early summer (possibly June) and left before the end of September.

He was visited on the island by a number of friends, and he also had with him – in addition to the crew of the *Elspeth*, which consisted of a skipper and at least one other person – a man who was known locally as 'the valet'.

The film was edited over the winter of 1934/5, and although there is a version of

its proposed opening lines in Kissling's own hand, the final cut that we possess today is different in tone and texture. A diary item in *Today's Cinema* of May 1935 describes a private viewing of 'a version of Dr Kissling's Eriskay' which is attributed to John Gifford, the named 'Editorial Supervisor' of the final print, so it may be that Kissling had to call in professional help after making an attempt at producing and editing the film himself.

The première was held at Londonderry House in London, at 9.30 p.m. on the 30 April 1935, as part of 'A Hebridean Evening' which attracted the patronage of the Prince of Wales and the Prime Minister. This was not in tribute to Kissling, but to the Marchioness of Londonderry, who was a regular organiser of events in aid of the Western Isles, which invariably involved the music of Duncan Morison and the participation of the London Gaelic Choir. Both Morison and the choir were also involved in Kissling's film, with Morison's music accompanying the credits and the choir contributing several times. The solo singer on the film was Sidney MacEwan, who would go on to achieve fame not just as a tenor but also as a Catholic priest.

The song that opens and closes the film is 'Island Moon', by Agnes Mure MacKenzie, whom I described in the Kissling biography as 'another Western Isles artist', only to be kindly rebuked by the formidable expert on all things Lewis, James Shaw Grant. Writing to me after the book's publication, he said: 'Agnes Mure MacKenzie was a very distinguished Scottish historian whose brilliant life of Robert Bruce had an immense effect on my generation. Much of her life was spent in the British Museum but, when she returned to Scotland, she was one of the leading members of the Saltire Society and gave me a good deal of support in my battle with the more obscurantist of our island ministers.'

He went on to point out that, as an Episcopalian, she was never given recognition on Lewis, and to contend that 'Island Moon' was not written for the film or for the concert première but was composed well before that for her brother on the occasion of his emigration to India.

The film achieved little notice and struggled on as a low-grade 'B' documentary feature for a few months before ending up in a school catalogue, and although Kissling had anticipated building on it with a much larger-scale production, nothing seems to have come of that either.

Kissling returned to Eriskay almost every year until the war, often staying at a house owned by a Mrs Johnston, though he also spent longer periods at the Lochboisdale Hotel, always occupying the same room and taking photographs, which, almost uniquely for a photographer of his standing, he did not develop himself, but always sent to the same company in London for processing.

He took up various causes for the people of Eriskay (the proceeds from the première had gone to build a road on the island, still called Rathad Kissling), including that of calling for the provision of a safe water supply. He also helped young people from the island and from South Uist to find employment on the mainland.

For most of the time, however, Kissling was busy in Cambridge or London, studying and socialising. He visited America on at least one occasion, and there are reputed to be photographs from his time there – including pictures of Arizona – though their whereabouts cannot be ascertained at present. As already indicated he also went to New Zealand, but again the bulk of photographs from this trip are not in any of the main collections, though there are a few in Dumfries which did feature in his 1978 retrospective exhibition.

There are many photographs, however, from South Uist and Eriskay which date from 1934 onwards. These usually feature people who also appear in *A Poem of Remote Lives*, although Kissling travelled more widely in Uist and took pictures at Loch Carnan in the north of the island as well as at Garrynamonie in the south. These are nearly always pictures of traditional crafts, involving older people, though there are some fine interiors and also occasional pictures of children.

Even after his release from the internment camp, the Western Isles was off limits for someone categorised as an alien – particularly one whose brother was a senior Nazi officer. Even his brother's role in the Colonels' Plot could do nothing to alter his status, and he was certainly aware of what was happening in Germany, of his brother's suicide and of the difficulties that then arose for his remaining family.

It was only in 1947 that he returned regularly to South Uist, taking his usual leisurely route from Cambridge via the Borders, Edinburgh and Argyll and on to Oban or Mallaig, always driving his little black Austin.

Some weeks after *A Poem of Remote Lives: The Enigma of Walter Kissling* was published, I received a letter on House of Commons notepaper from Tam Dalyell, the Member of Parliament for Linlithgow and now the Father of the House, which said: 'It was with mounting pleasure and interest that I read your book, over Christmas, on Werner Kissling. From my childhood memories at Lochboisdale you have, allow me to say, painted a superbly accurate portrait. Congratulations and thank you for preserving a memory which would soon have evaporated.'

I subsequently debated with Tam at the John Smith Annual Memorial Event at Glasgow University and he told me more about his meeting with Kissling in the late 1940s. He had visited Uist with his parents and had stayed at the Lochboisdale Hotel where Kissling was, as usual, in residence. He had gone with him to the *machair* on the west side of the island and recalled the distinguished, learned and very enthusiastic doctor, who seemed to know all there was to know about local ethnology and lifestyles, as well as much about the world farther afield.

James Shaw Grant also remembers Kissling at the Lochboisdale Hotel, where: 'I met him once by chance and we spent an hour together, half way up the stair, having an animated discussion on Highland affairs.'

In late 1997, while undertaking a number of engagements to promote the book from Dumfries to Stornoway and, of course, on Eriskay itself, I met many others who had known Kissling and who had personal memories of him. These varied from

an elderly lady in Kirkcudbright who had attended local history lectures that he gave in Galloway in the 1970s – when he would have been approaching eighty – to middle-aged men in the Western Isles who remembered his kindness to them as children and the fact that he would usually show his film and some of his lantern slides during his visits.

And there were other stories too, backed up by a wealth of new material. For example Jim Crawford, a celebrated stonemason living in Lewis, remembered Kissling from his days in Melrose and recalled his talking of a trip to Bayble in Lewis in 1936 when he had been mistaken for a German spy by some youngsters who could not understand his interest in the local black houses. Jim Crawford had also been given photographs by Kissling and confirmed his inability to deal with money or practical realities.

Another recipient of photographs – this time in the form of glass slides – was Amanda Broll's husband, in Dumfries. He had bought them, along with an old Leica (possibly Kissling's own, which he sold in a pub in Dumfries in the late 1970s), from a photographic shop in the town that was closing down. She brought them to the book launch in Dumfries, having read about Kissling in newspaper reviews. There was no doubt what they were, though all were copies of items in existing collections.

Some days after receiving Tam Dalyell's letter I received another from a Mrs MacLean in Fort William. She had read a review of *A Poem of Remote Lives* in the *Sunday Express* and wanted to know where to get a copy. I was especially intrigued by the letter, for she wrote: 'We knew him at the Kings Arms in Melrose, as my sister and her husband managed the hotel and we had many a happy and interesting night there with him and he was great fun with our four sons.'

However Kissling's own sojourn at the Kings Arms in Melrose was not, ulti-mately, a happy experience. He had purchased the hotel in 1952, with the main intention of having a place where his mother could stay whilst he pursued his many interests. She had joined him in Cambridge at the end of the war – having been virtually smuggled out through Austria as a result of an arrangement made by Werner's lifelong friend Andrew Croft – but was not content there. Kissling hoped she would prefer life in a small country town, but those who knew her there maintain that her mood did not improve.

Werner had spent considerable sums from his inheritance looking after his mother in England, and a document sworn in front of a notary public in Melrose in 1954 puts an estimate of the total at £6,300. This was entered into in order that Werner might have made over to him his mother's claims for war damage and compensation, as well as the last of the family property that she owned. As the family had been deprived of its property and income by Nazi diktat, this agreement would have been instrumental in supplementing the wealth that Werner had been able to bring to England before the war, and he subsequently went to law in the

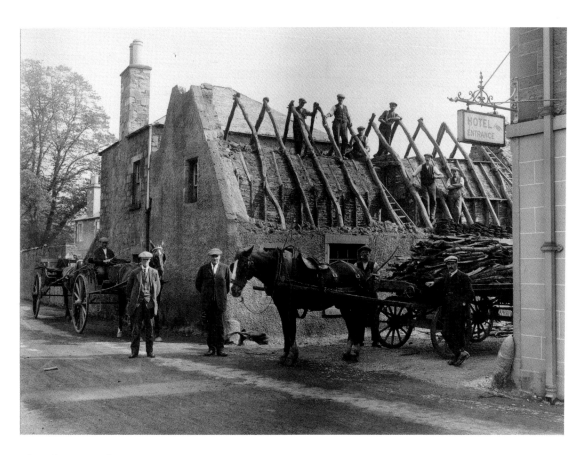

Thatching, Melrose, *c.*1910
The house is next to the Kings Arms Hotel, owned by Kissling during the 1950s and 1960s and the source of the financial troubles that left him penniless by the 1970s. The photograph dates from the early part of the century and probably was found by him in the hotel.

American zone of his defeated homeland to gain what he regarded as his rightful property. The rest of the family was not impressed and regarded Werner as having made off with the family inheritance. The matter was the source of a rift that lasted between him and his nephew and other family members almost until his death.

Werner was no businessman and no manager of money. The hotel was a pleasant indulgence but not a profitable business – or at least not the way he ran it. Many people, including the noted folklorist Calum I. Maclean, remembered nights in the hotel when drink would flow and conversation last into the small hours. Those who took the job of managing the hotel had difficulty persuading Werner to draw a line between his personal expenses and the needs of the business.

During the 1950s and early 1960s Werner became even more prolific in his

photographic activities. He travelled extensively in the Scottish Borders and in the West Riding of Yorkshire, recording crafts and traditional ways of life and selling the resulting photographs, with notes, to universities and archives who were willing to pay. Obviously the money was already running out and he needed to supplement his income in the only way for which he was qualified, although the institutions he targeted become more and more reluctant to support such a maverick practice. His correspondence of the time has creeping into it an increasingly desperate note.

Werner's mother died in 1961 and the hotel staggered on for a few years, though the losses continued to mount. Bernard Lawson – Mrs MacLean's brother in law – managed the hotel for a decade and the relationship between the Lawson family and Werner was close enough for him to act as godfather to Christopher Lawson when he was christened in the Episcopal church in Melrose in July 1954, and for Werner to keep the certificate naming him as such in his suitcase of papers until his death.

By the age of seventy Werner was broke. The hotel had to be sold – most likely as a result of a long-term fraud perpetrated on Werner by two individuals in positions of trust in the community who had frequented the hotel's cocktail bar – and Bernard Lawson, by this time a business partner in the enterprise, left to seek work elsewhere. Werner gravitated west, to the town of Dumfries, where he would spend the rest of his life.

I was glad to get Mrs MacLean's letter and gladder still to spend an afternoon with her in Fort William, both because of the detail she added to Kissling's time in Melrose and because of other light she was able to shed. I had thought, having been to the hotel and spoken to a local informant still living close to it, that her brother-in-law might have been the cause of the financial collapse as I had hinted in the biography. Certainly in his later years Werner blamed a range of people, including Bernard Lawson, though rarely himself. Her version of events, including the naming of names, which cannot yet be published, seems much more credible and much fairer on a man who also lost a great deal in the débâcle.

Werner Kissling came to live in Dumfries at some stage in the mid 1960s, eventually settling in a small rented flat near the town's museum. Now over retirement age, he was virtually penniless and unable to live on the small state pension. Accordingly, he set out to try and earn some money, contributing articles to the *Scots Magazine* and reselling photographs he had taken in previous years. He also embarked on a career as a freelance collector of items for the Dumfries Museum, eventually winning a small honorarium in recognition of his activities.

It is legitimate to ask, 'Why Dumfries?', but in reality Kissling had come to know most of the Border and Galloway towns well when he travelled looking for people and things to photograph, and I suspect he chose Dumfries because it has the biggest and best museum in the area, and was also the place he could most easily find a cheap place to live. He frequently said how much he liked Dumfries, and that would

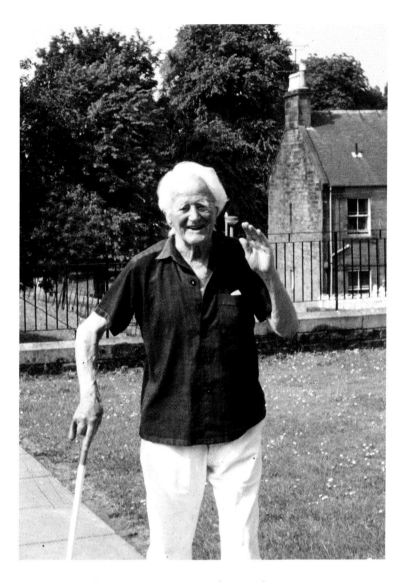

Werner Kissling at Swans' Vennel, Dumfries, c.1985.
Photograph reproduced by kind permission of David Lockwood.

seem as good a reason to stay there as any, particularly as there was nowhere else that would give him any warmer a welcome.

He became a 'weel kent' figure in some of the local pubs, for he would usually find the price of a glass of whisky, and made some good friends in the town who were ready and willing to help him as the inevitable problems of old age approached. He had frequent difficulties with officials of all sorts, whether they were tax inspectors trying to fathom out what had happened at the hotel or DSS clerks who found it hard to believe that he had no record of his previous periods of employment despite his many national and international contacts.

In the autumn of 1978 Dumfries Museum held a 'retrospective' exhibition of Kissling's photographs, arranged by himself but with an introduction to the flimsy catalogue by the former museum curator, Alfie Truckle. The museum basement already had a sizeable holding of Kissling photographs from different places and times and the exhibition revealed what he thought was his best work, featuring as it did twelve sets of prints from the Western Isles, seven from New Zealand and fourteen of largely Borders and Galloway traditional crafts or artefacts. The final print was a picture of Kissling, taken by David Lockwood, the museum's young new curator.

As Kissling approached his eighty-fifth year he began to rely more and more on Lockwood, in whom he also confided. He regarded his real and lasting achievements as arising from the work he had done in Eriskay, and subsequently in Cambridge, and he became hungry for a wider audience for the images he had captured – though he did not want personal publicity for himself. This situation might have arisen out of his reduced circumstances (he was, according to his Dumfries friends, never bitter about the financial problems of his final years, though he could get frustrated by them) and perhaps also from his homosexuality, which he had more or less hidden during his life but which he seemed to have no difficulty in talking about to close friends.

There was a second, larger exhibition of his work in 1983, which resulted in more interest, though the local newspaper headline ('Brilliant Work of County Nazi Victim Goes on Display') prompted him to tell Andrew Croft in a letter that he regarded such articles as 'provincial, and rather touchingly so'.

Andrew and Rosalind Croft – then living in London – remained his closest correspondents and they even managed to visit him on occasion, bringing him a music centre so that he could play again and again his favourites, especially the records of Mahler's third symphony which he had taken with him to Eriskay in 1934, along with a wind-up gramophone.

His health continued to deteriorate – he had lung problems and arthritis – but he remained actively interested in the work of the museum, expressing in 1987 the hope that as the museum's role was widened to serve the whole of Galloway, he would be 'fit enough to help putting what was my concern in reasonable order'.

It was not to be. His failing eyesight led to permanent residence in a nursing home, in which he longed for visitors and enjoyed himself hugely when they came. In January 1988 he appointed David Lockwood as his executor and entrusted to him what few possessions he had, including the large suitcase which held the story of his life.

David Lockwood, in a letter to Andrew Croft, recalled Werner's last lucid night. 'He was never brighter,' he wrote, 'and loved the excitement – at one stage he had three drinks on the go, whisky, tea and water. This night is the one I think about. The memory will stay for a long time.'

Werner Kissling died within twenty-four hours, on 3 February 1988, just two months short of his ninety-third birthday. For a man who had lived so much of his life for himself and out of the public eye, the public appreciation was unexpected. *The Times* obituary spoke of him as 'a man of high principle, intense idealism and great sensitivity . . . with a gift for friendship', while the *Daily Telegraph* noted 'Hitler's arrested secretary dies', peddling again the untrue story of the arrest at the German embassy in 1933. The *Scotsman*, however, gave the most fitting tribute of all – a Gaelic appreciation in its regular Saturday Gaelic column. He had learnt virtually nothing of the language, but, like many other sympathetic recorders of the place, he had gone straight to the hearts of its people and their culture.

Images of the Western Isles

A full and wide-ranging study of the images of the Western Isles is long overdue, but this is not it. Such a publication would entail much research on painting, drawing and photography, and to be effective it would need to be set against cultural, social and economic perceptions and the realities of the relationship, not just between the remote west and the increasingly centralised south and east of Scotland, but with Britain as a whole.

Such a study need not, of course, be devoted exclusively to visitors from within Scotland and Britain. Even in this short piece I shall mention a German (albeit one who spent more than sixty years in Britain) and two Americans. One could add many others from many other different places.

However, all I can attempt here is to look briefly at some ways in which the Western Isles – and more particularly the southern part of the Western Isles which I know best – have been portrayed over the past three centuries or so by those who come from outside – from other parts of the British Isles and farther afield. I have inevitably concentrated most on twentieth-century photography, because that is what this whole book is about, but twentieth-century photography does not stand in isolation from other means of image-making and reporting or recording what lies beyond our ken. And I have drawn everything back ultimately to Werner Kissling.

Dr Johnson is reputed to have observed, inevitably to Boswell, that the inhabitants of Hirta – the modern St Kilda – could have little or no poetry or song, or indeed any artistic endeavour, because of the poverty of imagination that he believed would arise from their remoteness and lack of intellectual stimulae. Johnson was wrong about a great deal in Scotland, and wrong about that most of all. Poetry, song and artistic endeavour arise from many circumstances, and the more the contrast between the modest scale of human life and the overwhelming scale of nature and her forces, the more individuals are caught up in the interplay between emotion and reality, which is one of the wellsprings of art. The more also they express it in their own way and in their own language.

It was, of course, the remoteness of the north and west of Scotland that encouraged Johnson – or encouraged Boswell to encourage Johnson – to visit the Hebrides between August and November 1773. They were not the first visitors to come back with stories to tell and sell but they were, and certainly still are, the best known. However, their contributions belie the dictum that Johnson himself pronounced: that 'Exactness is first obtained, and afterwards elegance'; their respective versions of their travels are elegant but not exact.

Johnson prided himself in not having a 'mind naturally acquiescent and a credulity eager for wonders'. He was sceptical about what he heard and saw, noting that the inhabitants of the Hebrides 'are not much accustomed to being interrogated by others; and never seem to have thought to interrogate themselves; so that if they do not know what they tell to be true they likewise do not distinctly perceive it to be false'. This scepticism – some might see it as arrogance – colours his and others' views of the Hebrides and their people, and creates a distance of belief in what we are prepared to accept as being true for that part of the world.

Photography was one means of overcoming such subjective prejudices. Sketches and drawings – such as those that accompanied the published account of Thomas Pennant's voyage in northern and western waters the year before Johnson – were matters of selection, imagination and interpretation, not to mention individual talent. So were the aquatints and watercolours of amateur and professional artists who either visited the Hebrides of their own volition or who collaborated with writers and travellers to produce 'complete' accounts.

Photography is meant to freeze things in their place and to present them exactly as they are. But of course photography does not exist separately from knowledge and consciousness. It also depends upon pointing the camera at something, and therefore choosing a subject, just as surely as drawing or painting requires selection of a subject. So, in considering images of the Hebrides, we have first to ask, how were the Hebrides seen in the mind's eye of those who took or made the pictures?

Johnson's perceptions – more critical but more intelligent than most – were far from atypical in the eighteenth century. At that time a voyage to the Hebrides was almost impossible – as daunting as a voyage to the moon would be today, physically as well as intellectually. Roads were few and poorly maintained (General Wade had certainly made a difference on the mainland but not on the islands) and sea travel in crudely constructed boats was always alarming and usually dangerous. Even in the opening years of the nineteenth century, James Hogg, on his way to make an ill-fated attempt to buy a sheep farm in Harris, writes to Sir Walter Scott of the rigours of voyages full of cries of horror and alarm from the ship's crew and vomit and fear from the passengers.

People generally went to the Hebrides either because it was a brave thing to do or simply because it was a matter of distance – physical distance from the centre of civilisation (whether Edinburgh or London) and also distance of feeling and

experience. They also went so that they could talk about it afterwards, as tourists still do wherever they go, or write about it and make some return on their voyage, as also still happens.

Photography was invented just as perceptions of the Western Isles were changing and subsequent technological improvements made it possible to capture the last flowering of Hebridean culture.

The era of the 'impossible' trip had been laid to rest by Queen Victoria and her restless travelling through her queendom. In August 1847, the *Ban Righ* became the first reigning British monarch (and that species had been around for 244 years) to visit the Hebrides. The last Scottish king to make so bold as to circumnavigate Scotland was James V in 1540.

A royal squadron accompanied her majesty – partly for protection at a time when the potato famine along with the worst excesses of landlordism had Ireland in their grip and when echoes of both these problems were being felt amongst the Gaelic-speaking population of the Western Isles – but it was quite superfluous: she fell in love with the Highlands, even if it was the drier east that became her refuge of choice, rather than the wet and windy west (a preference that remains in the royal family to this day, Prince Charles and his Berneray potato patch excepted). And the Highlands treated her with the deference she felt she deserved.

But what she brought on her sole visit to the Hebrides – even though she got no further than Staffa and Iona – was more than a royal presence: it was a warrant of approval and a spur to those who would imitate anything she did. But whereas she had come and gone, many others came and tried to interfere, principally to ensure that there was game and fish enough for them to hunt in the summer season.

Some there were, however, who were only interested in the new science or art of photography, which was born in Scotland almost in advance of anywhere else. 2002 sees the bicentenary of the birth of David Octavius Hill, who, with Robert Adamson, created about 3,000 photographic images in the four years from 1843, an enterprise which, in terms of both chronology and quality, places them at the forefront of the history of the medium. Paul Strand (a name we shall come back to) regarded the contribution of Hill and Adamson to world photography as so great that he insisted that the whole of the first gallery in his 1937 'Century of Photography' exhibition at the Museum of Modern Art in New York be given over to Hill and Adamson in its entirety.

Hill and Adamson were not only pioneers of photography, they were pioneers of documentary photography. Their series of photographs of Newhaven by the Forth was designed as a documentary record. This legacy of the photographer as recorder, not just as a maker of pictures, would be of great importance in the Western Isles a century later.

Little has been written on photography in the Western Isles during the nineteenth century, so it is difficult to form a comprehensive view of the impact of the medium

at that time. There are certainly images by George Washington Wilson and by James Valentine which have often been reproduced. John Francis Campbell (Iain Og Ile), the extraordinary collector of folk-tales, champion of the crofters and eccentric, took photographs in places other than his native islands, but there is nothing published that includes photographs he might have taken closer to home, even though his sketches and drawings of Hebridean subjects have survived.

Mass-produced postcards featuring photographs of many hundreds of different scenes in the Western Isles were available widely by the 1890s. One such postcard of St Kilda belonged to Werner Kissling for almost all his life, having been sent by his mother when on her tour of Scotland in 1905. His collection of glass slides in the Dumfries Museum also includes two pictures of St Kilda taken about that time, perhaps an indication that his mother was also a photographer and had taken these herself.

There is therefore no shortage of individual items that illustrate the way in which the Hebrides were seen from about 1870 onwards, but there is a lack of sustained documentary material of the type that would distinguish photographers of the Hebrides in the twentieth century.

The years after Queen Victoria's visit were not easy ones in the Highlands and Islands. Landless 'squatters', as they were called, were evicted ruthlessly from their homes, and every effort was made to diminish the reach and use of Gaelic. The vast increase in tourist traffic had created a mood in the rest of Britain that this particularly 'backward' area needed a jolt into the nineteenth century, yet at the same time this point of view contrasted with a desire to ensure the continuation of the 'sturdy and hardy Highlander' with all the virtues that it was imagined he could contribute to the well-being of the Empire.

These curious contrasts can be seen in art as well as in reportage. Thomas Faed's painting *The Last of the Clan* (1865) is an emotional, if not sentimental, snapshot of the soul-destroying effects of emigration, which also has overtones of the damage that is being done to the country in clearing its people. This is ironic, given that some of Faed's clients and patrons were the very people who were forcing the Highlander into exile.

Faed's picture – and others of that genre such as *Lochaber No More* – are the Victorian antithesis of Raeburn's Georgian portrait of Alasdair MacDonell of Glengarry (1812), which portrays pride and responsibility (though MacDonnell had much of the former and very little of the latter: a personal rage against change resulted in him physically assaulting those who tried to dig the Caledonian Canal over his mortgaged land).

Faed's picture has its equivalent in the literature of the time, of course, but the strongest expression of those desperate times is found in song, both in Gaelic and English, and most memorably those lines heard in Canada by a traveller – possibly Irvine's own John Galt:

From the lone sheiling of the misty island
Mountains divide us, and the waste of seas –
Yet still the blood is strong, the heart is Highland,
And we in dreams behold the Hebrides!

Scott's 'Caledonia, stern and wild' was being turned into unpeopled deer forests, endless sheep-runs and wild pleasure grounds. The world of Turner's chaotic vision of the Cuillins, in an almost living and energetic sweep dwarfing the two tiny observers was, in a backward step, being turned into the empty, lowering, but elegant Hebridean aquatints by William Daniell.

The human landscape was being reordered for the benefit of the few at the expense of the many. But the many were about to fight back.

Some of the first signs of this spirit were noticed in the Highlands during the recruiting campaigns for the Crimean War, all summarised by that famous rebuke, 'Since you have preferred sheep to men, let sheep defend you.'

Soon there was disorder everywhere, if one is to believe the London journalists who arrived in their throngs at the first sign of trouble, or the London-based landlords who spied anarchy and revolution in every respectful petition. Queen Victoria apparently could not understand what was happening to her loyal and noble West Highland subjects, the ones she had last glimpsed from the royal yacht or from the barge floating into Fingal's Cave, its crew 'dipping their oars with the greatest precision', ensuring that 'nothing could be so animated and grand', as *The Times* reporter put it.

In reality there were a number of outbreaks of justified and sometimes long overdue resentment at the imposition of conditions of tenancy or clearance which would have resulted in considerable hardship and probable emigration. Press photography was not yet in frequent use, so the illustrations we have of marines arriving in Skye and police constables being distrained and deprived of their helmets were the work of artists, either sketching very quickly or drawing what had been described to them. Polemical books and pamphlets in defence of the Highlander or in self-interested justification of the rights of property were also full of line drawings. Donald Ross's *Real Scottish Grievances* of 1854 has a number of illustrations which must be the work of imagination, especially that of Lord MacDonald's evictions at Boreraig in Skye, which is complete with a frock-coated and top-hatted villain, pointing at an emigrant ship for the benefit of plaid-covered Highlanders, one of whom is feeding an old crone porridge.

Descriptions of the harshness of life were also drawn rather than photographed. The illustrations in C. F. Gordon Cummings's *In the Hebrides* are superb examples of their type, with something in common with Kissling's photographs of traditional crafts and activities taken sixty years later.

One important landmark in the history of the Hebrides is also a defining moment

in their portrayal. The work of the Napier Commission in 1883, established to bring peace to the Highlands by means of righting at least a few of the wrongs suffered over generations, coincides with some of the first photographic records of the actual lives of the Highlanders. Certainly the Commission did not need photographs to help it in its work, and many of its findings were illustrated by line drawings. But there are also photographs of crofts and crofters dating from the time, and such photographs give historical veracity to what the Commission discovered, as well as some sense of the circumstances in which their work was conducted.

One slightly later example of photography from the Hebrides that was different from picture-postcard material or the type of important reportage surrounding land agitation and social progress is found in an obscure book about North Uist written by an English antiquarian, Erskine Beveridge, and published in 1911. Beveridge went to North Uist in 1897 with the purpose of comparing the island's prehistoric forts and duns with those to be found on Coll and Tiree, which he also recorded. The book contains 150 full-page plates, some of which are drawings of plans or selections of pottery and other items. But there are a considerable number of photographs of actual forts and duns, at least one of which includes a woman in a staged pose, presumably for scale. There are also a very few contemporary photographs – for example of the Fair at Lochmaddy – and the effect of the whole is to produce a type of documentary record, albeit one which is very specialised.

Because the original of the book is rare, Beveridge's qualities as a photographer have not been properly assessed. However, a superb reproduction published in 2000 by Birlinn (happily using a copy of the book that belonged to my wife's father) allows one to study Beveridge as a photographer for the first time.

Beveridge is a recorder of items rather than of people, and his photographs tend to be somewhat long-distance given the subject matter. None the less they are sharp and accurate and convey the atmosphere of the island very well. This sense of rock and water being the main elements is true of North Uist, and even the picture of Lochmaddy Fair is one of a huge horizon rather than of a busy event.

Beveridge was using photography for illustrative purposes and was not a professional photographer. It is precisely this approach that turns out to be the most common in the twentieth century as far as photographs of the Western Isles are concerned, just as many illustrators and artists drew images of the area for inclusion in books, magazines or newspapers in the eighteenth and nineteenth centuries.

Alasdair Alpin McGregor is a case in point. Born in 1898, he wrote on both Scottish and Hebridean topics and often took photographs to illustrate his work. A collection of his photographs is held by the Museum of Scottish Country Life at Kittochside, near East Kilbride, and there are also examples in the collection of the School of Scottish Studies at Edinburgh University.

Although he became massively unpopular in Lewis as a result of some foolish written criticism he made of the island, McGregor's work on the Hebrides is of great

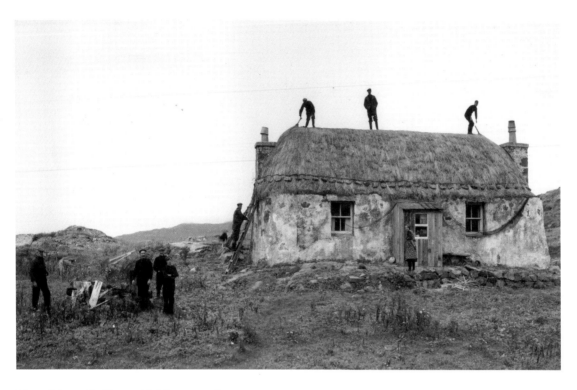

Thatching, Coilleag, Eriskay, no date.
At Johnstone's 9 Coilleag; photograph by A. Alpin MacGregor

importance, covering as it does a long and crucial period in the twentieth century when traditional ways of life were rapidly dying out. No sustained essayist concentrating on one place, his range of locations and subjects is also valuable, although inevitably there is a superficial quality to some of the work, the subjects of which seem glanced at rather than studied.

Margaret Fay Shaw – the wife of the great Gaelic scholar and writer John Lorne Campbell of Canna – is another example of the photographer who uses their skills to complement their main activities. An American, she spent some time living in South Uist between 1930 and 1935 and her best photographs illustrate her researches into folksong and folklore, adding human faces to music and text. Having learned Gaelic to fluency – almost uniquely amongst photographers who worked in the Hebrides – she was able to penetrate Hebridean culture more thoroughly and to get close to the rhythms of the place, something that can occasionally be seen from her photographs, for example in her fine, almost snatched, study of men and women resting while herding cattle.

M. E. M. Donaldson was another scholar, specialising in Scottish history and in particular in Church history. However, she was also a skilled and virtually professional photographer, who travelled with what she called her 'mobile field'

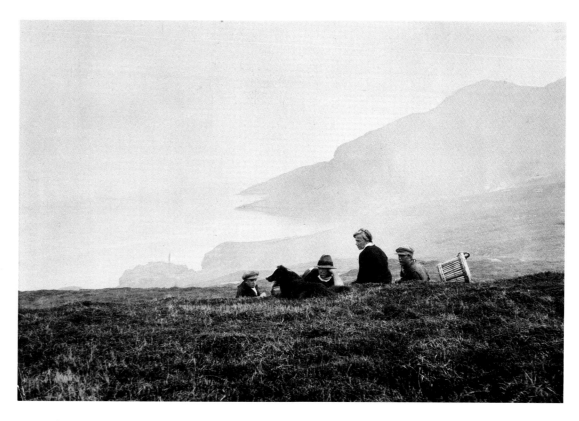

One of Margaret Fay Shaw's photographs, collected in her ground breaking-work, *The Folksongs and Folklore of South Uist*. This one shows Donald McRae, Angus John Campbell, Mairi MacRae and James Campbell resting while hearding cattle in South Uist; reproduced by permission of Margaret Fay Shaw.

photographic van over a wide area, including the Western Isles, during the 1920s, although her entire collection covers the period from 1900 to 1930. That of a remarkable woman, her archive is also housed in the Museum of Scottish Country Life, which shares some of her work with the Inverness Museum.

Which leads us to Kissling himself. Perhaps his talent lay in the fact that whilst he believed he was taking photographs to illustrate his anthropological studies, he was not a great ethnographer but rather a great photographer. Working through any archive that contains his photographs mixed with, for example, the work of Margaret Fay Shaw, Alasdair Alpin MacGregor or a host of others, it is soon easy to pick out the Kisslings just by eye. They have a sharpness and a clarity that others lack and these qualities are the result of a number of factors – the use of precision equipment, a high degree of technique and good-quality development (Kissling never developed his film, but sent it to the best firm in London). But more than that, their composition is nearly always perfect. In Margaret Fay Shaw's

photographs individuals can be self-conscious, darting nervous looks at the camera, or the edges can be ragged with extraneous details. Never in Kissling's. Likewise with Alasdair Alpin MacGregor, who photographed a similar house in Eriskay to that in which Kissling stayed in the 1930s. Kissling's picture is immeasurably superior, though it has far fewer people in it, and is more studied. The little that is there speaks volumes.

Kissling and Margaret Fay Shaw undertook sustained visits to particular places where they could develop a way of seeing that linked items to the landscape and people to their surroundings. Photographers without the benefit of even temporary roots tend to show the nature of their relationship to a place merely visited, not known.

Both Kissling and Shaw are concerned with documentary rather than reportage, an approach which also characterises *A Poem of Remote Lives*. Kissling's film, interestingly enough, contrasts with two other notable films from the same year – Robert Flaherty's *Man of Aran* and Leni Riefenstahl's compelling celebration of the Nuremberg rallies, *Triumph des Willens* (*Triumph of the Will*). Flaherty was an 'imagined documentarist', who based the action of his film on real events but was quite prepared to add creative touches he felt would benefit the film (such as the famous storm scene, for example). Riefenstahl, on the other hand, was a propagandist, who deliberately framed her shots to make a point and juxtaposed images to engender a reaction.

Kissling is an observer, content to tell a story simply by means of looking and recording. He does not impose himself or his preconceptions, but lets the image speak for itself. His view is closest perhaps to that of the modern photographer Gus Wylie, who has taken many pictures in the Hebrides, and who said in an interview in 1999, 'It's all to do with valuing the quality of life, trying to record it and hoping that other people will value this too.'

Speaking more generally towards the end of his life, Kissling put his photography in this context: 'Everywhere today new houses are being built to uniform specifications: the old black house has disappeared – not necessarily a matter for regret – but with it has disappeared many a ceilidh and by degree the desire for spontaneous self-expression by the people, be it in song or in poetry, the making of tools or the dyieng of home-made tweeds. Can they – and can we – do without it?'

The only truly great international photographer who has spent time in the Western Isles was Paul Strand. In 1954 he and his wife spent three months in South Uist, which resulted in the famous collection *Tir a'Mhurain*, or *Land of the Bent Grass*, one of the Gaelic names for South Uist.

Out of print for almost half a century, the photographs have recently been republished in a new edition, which is a joy to browse through. Strand wrote on photography and saw the act of taking a photograph as an expression – 'however subtle', as he put it – of the photographer's own 'values and convictions'.

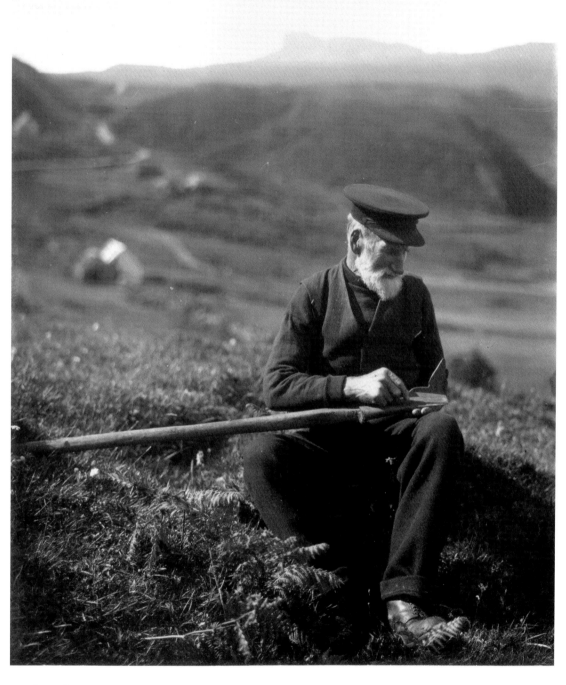

Turf spade, Eigg, 1936
Photo by M. E. M. Donaldson
The studied nature of the photograph is typical of Donaldson.

Kissling's is a loving and sympathetic eye. His portraits are close-ups, with each line of the face fixed and the subjects usually in attitudes of communication or studied repose. His landscapes and interiors are full of detail, rich with patterns and images. Overall there is a fluent but unobtrusive feeling of growth – the creation of a documentary record of one place at one time which will stand for all such places at many times.

Strand took a limited number of photographs, but took them superbly well. Kissling took many photographs (sometimes many of one process of action in order to get all the stages of, say, the building of a barrel or the plaiting of a horse-hair rope), none of which fall below a high standard, but a few of which (and there are a few) reach Strand's standards. It is safe to say that no other Hebridean photographer of the twentieth century managed that.

And what of today? A search on the internet for Hebridean photographers or photographs produces some archive material – including those well-known records of the Guga hunt on Sulesgeir and some fairly stock landscapes and cloudscapes, usually for online sale. All quite attractive, but then it sometimes seems that it is hard not to take a good photograph in the Hebrides if you are at all able to point a camera and wait for the right moment.

Gus Wylie's two books of Hebridean photographs are exceptions to the normal rule. He has the ability sometimes to make the place look ugly, and that is not a criticism. It is a necessary part of showing all the aspects of the place and people, and Wylie is one of the few who has spent enough time to see it all and understand that fact. He is also a fine recorder of the quirky that speaks volumes, as in his famous 'Keep Out' photograph that defines the present problems of landownership and distant control.

The early talent of Calum Angus MacKay for seeing patterns and things instead of merely photographs has not been fulfilled in recent years, though it is not too late for him to flower as the photographic talent he could be. The Western Isles could do with a Patricia MacDonald with a unique way of seeing, but it has not found one yet.

It had an Oscar Mazaroli, as the well-known photographer of Glasgow life in all its rawness was also a *habitué* of Lewis. I remember a dinner with him in Stornoway when he told a story – sceptically it has to be said – of the reputed power of the Callanish stones to start watches that had long stopped. I recall it particularly because my wife's watch, which had broken the day before, started again at that very moment.

And the Hebrides have had a succession of press photographers – including the best – who have tried to see the islands through different eyes and lenses and make something new. But even they, schooled in hit-and-run recording, which is meant to represent truth, cannot quite get at what is there. Or rather they cannot quite rise above their society's accepted perceptions of what *is* there.

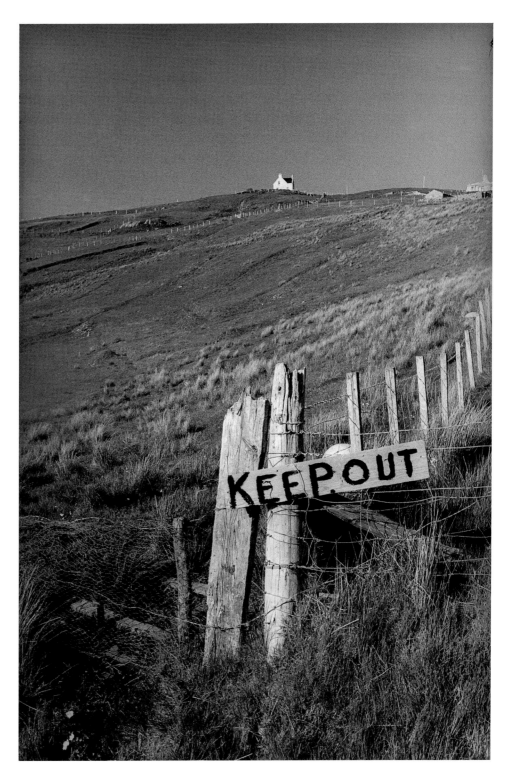

'Keep Out', Elgol, Skye, by Gus Wylie, the best modern photographer of the Western Isles and who admits to the strong influence of Paul Strand on his work; reproduced by permission of Gus Wylie

Johnson and Boswell were dismissive of the feckless and dissembling natives, far removed from their culture and experience. Queen Victoria saw a grand landscape with attendant loyal people, but in reality they were pressed down by hardship, want and exploitation, in physical circumstances that could not be borne for ever. George Washington Wilson and his contemporaries made postcards out of them; Erskine Beveridge recorded the past and little of the present. It took until the 1920s before the Hebridean culture and world view were valued and visibly recorded – and by then it was almost too late, just as audio recording came almost too late to preserve the oral tradition.

Today there is still a culture and a world view, but they are inevitably intermingled with what emerges from television, or can be entered into by an hour's plane journey or a few hours' drive. It is not so different from what the majority experience, particularly now as the bearer of that world view, the language, is in a perilous state – battered by indifference, starved of resources and legislatively neglected by a government that promised much more in the first Scottish Parliament for three hundred years.

But Fay Shaw, MacGregor, Donaldson and – greatest of all – Kissling were around at just the time when the camera, as a device that was comparatively easy to use, met the last flowering of something different. It was there in all its 'spontaneous expression', though it was fading even as they lived amongst it or visited it. They were interested in other things within that culture, so they delved deeper than most, and their ability to use photography to hold on to what was precious and allow us to see it has turned out to be their greatest and longest lasting contribution.

That something which was beginning to die was the same thing noticed by Thomas Hardy in his *Life,* when he observed that in his beloved West Country, ' . . . the changes at which we must all rejoice have brought other changes which are not so attractive . . . for one thing village tradition, that vast mass of folklore, local chronicles, local topography and nomenclature, is absolutely sinking, has nearly sunk, into eternal oblivion.'

And George Thomson, the recorder of the culture of the Blasket Islands off the Kerry coast in Ireland, saw it happening there too. But he was more positive than Kissling and Hardy, suggesting that 'civilisation has always advanced through conflict, bringing losses as well as gains, but the losses may be made good in the future if we can learn to draw inspiration from the past'. That view may arise from the fact that the heritage of the Blaskets from its last flowering is a literary one.

Images, unlike stories and songs, are not only frozen in time but also permeated with the culture of the time they were made. They are not recreated and re-edited by the process of performance or recitation. The best images of the Hebrides carry two cultures – that of the culture observed and that of the culture of the recorder. Perhaps that is partly what makes them so rich and so popular.

Werner Kissling – a man spread across cultures – wore his own very lightly. It was

no hardship to take on another equally lightly (he never learned Gaelic or even tried to, although his film is the first to use Gaelic), but he became addicted to it.

Allan MacDonald, the Gaelic television producer, tells the story of the only time he met Kissling, whom his father had known in Eriskay. Kissling was old and living in poverty in Dumfries, but his eyes lit up in talking about the island and his time there and eventually he cried.

Allan describes Kissling's photographs thus: 'To me, as an Eriskay man, I am looking beyond the outer layer of the photograph. I am making a spiritual connection to the people who have gone . . . and I see the lines in their faces, what is in their eyes, what they are telling me about their way of life.'

Maybe that 'spiritual connection' is what all images of the Hebrides try to give us, and maybe their success can be measured by the amount we are able to understand about a way of life and about the way that world was viewed.

That world which Johnson believed could not provide stimulus enough for his idea of art, provided stimulus enough for a flourishing and ancient culture, for a wide ranging and graphic language, and acted as a magnet for so many who wished to know – and for those who still wish to know – about the very margins of their own country.

TWO

The Photographs of Werner Kissling

Kissling's photographs exist in a number of archives. The photographs reproduced here are taken from the School of Scottish Studies. Work still needs to be done to identify and catalogue Kissling photographs in other collections, including that of Leeds Museum, to which he contributed much ethnographic photography from the West Riding of Yorkshire. Kissling often sold the same photograph to several organisations so all collections have duplicates.

As an ethnologist Kissling usually provided background notes to the photographs he sold. In some cases these are extensive and provide a complete description of the activity seen. The captions to the photographs in this book use many of these descriptions, supplemented by additional information and commentary from the author.

Eriskay 1934

Kissling's first flowering as a Western Isles photographer came in 1934 when he took a large number of pictures whilst also making his film, *A Poem of Remote Lives*. Many of the characters who appear in the film also appear in the photographs.

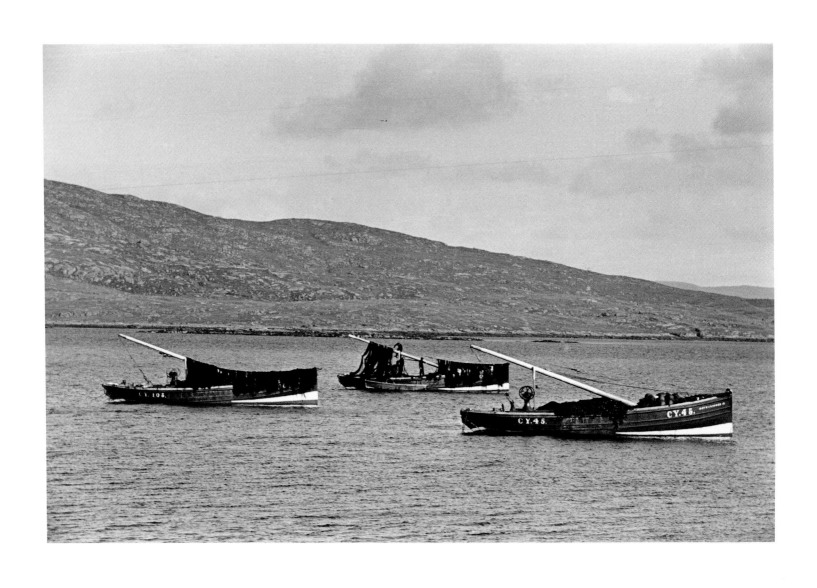

FISHING BOATS, *Eriskay, 1934*
These local boats are also featured in Kissling's film *A Poem of Remote Lives* and whilst
 Castlebay-registered were usually moored at the Harbour in Eriskay.

NATURAL HARBOUR, *Eriskay (east side), 1934*

The photograph was taken during Kissling's filming visit to Eriskay. The white yacht is the *Elspeth*, hired by him from Gourock for the summer of that year. He notes of the place: 'The island rises steeply from the sea in cold grey cliffs, to a height of about 600 feet, on the east side. A deep inlet below, with a narrow entrance, affords one of the safest anchorages in the Hebrides.'

LAZY BEDS, *Eriskay, 1934*

Kissling writes, in his note for this photograph: 'It is the preparation of the smaller patches of wet, shallow and rocky ground (too small even for the little horse-drawn plough or 'ristle'), which can be used profitably only for growing potatoes, that the *caschrom* is most useful. The ground here is divided into strips which are left unturned from 2–4 feet wide with furrows up to 3 feet wide between them. The soil from these is turned over surface downwards on to the unturned strips, generally with seaweed in between. (In the Black House days, the thatch when saturated with peat tar was taken off and might be used as manure instead of seaweed.) The dressed ridges were known as lazy beds.'

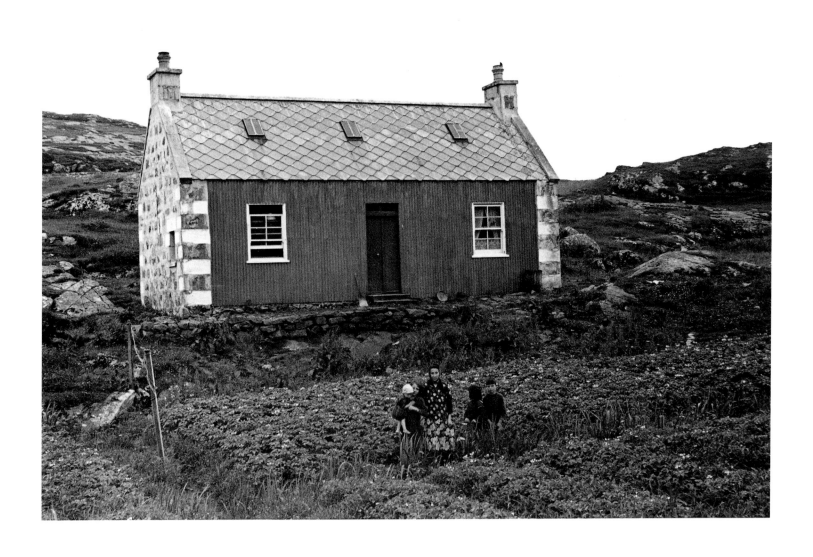

DWELLING-HOUSE, *Eriskay, 1934*
This is Ronald MacInnes's house on Eriskay, where Kissling stayed for part of his 1934 visit.
The sound of his wind-up gramophone, playing Mahler, could be heard across the hill.

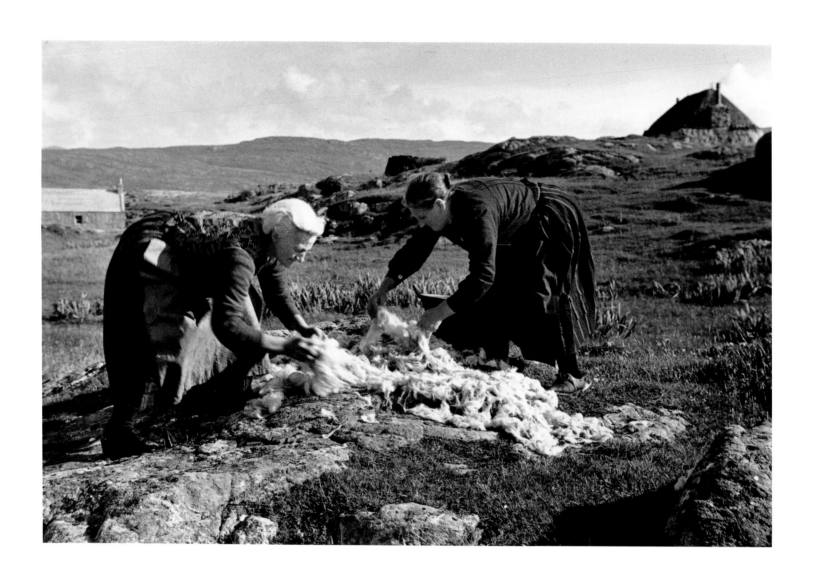

WOOL-DRYING, *Eriskay, 1934*

'Wool being laid out to dry after washing; note women wearing *drouguet*, a home-made ribbed woollen dress.' On the left, Mrs Mary Johnston and right, Mrs Mary MacIsaac.

 All Kissling's photographs of wool and associated industries taken in 1934 supplement the extensive film record he made of traditional wool-related crafts.

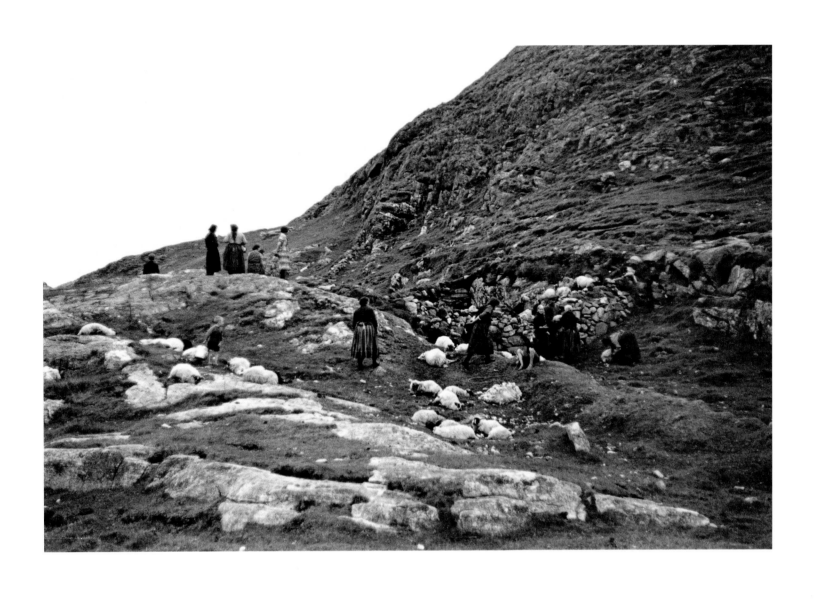

SHEARING, *Eriskay, 1934*
Sheep-shearing; note women wearing *droguet*.

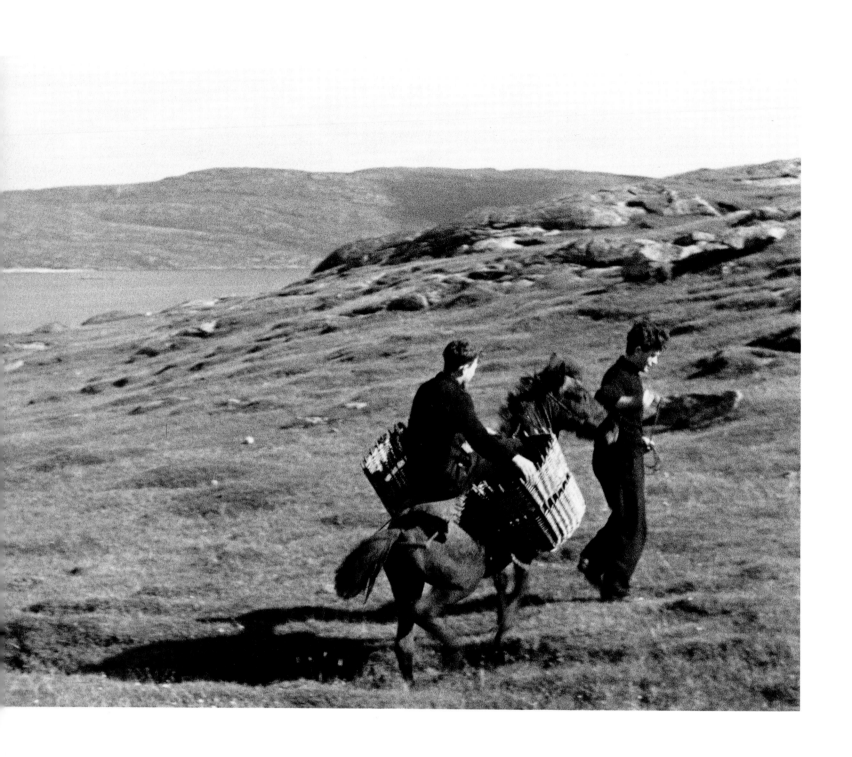

CARRYING PEAT, *Eriskay, 1934*

The Eriskay pony is a breed unique to the islands and is now protected and encouraged by the Eriskay Pony Society.

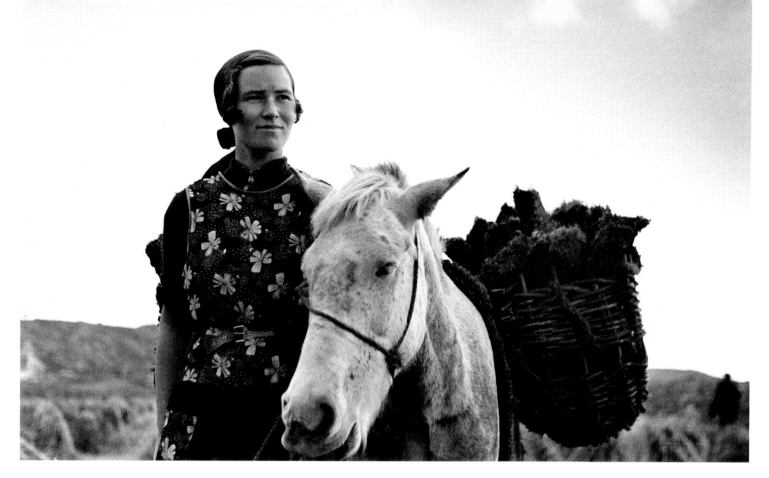

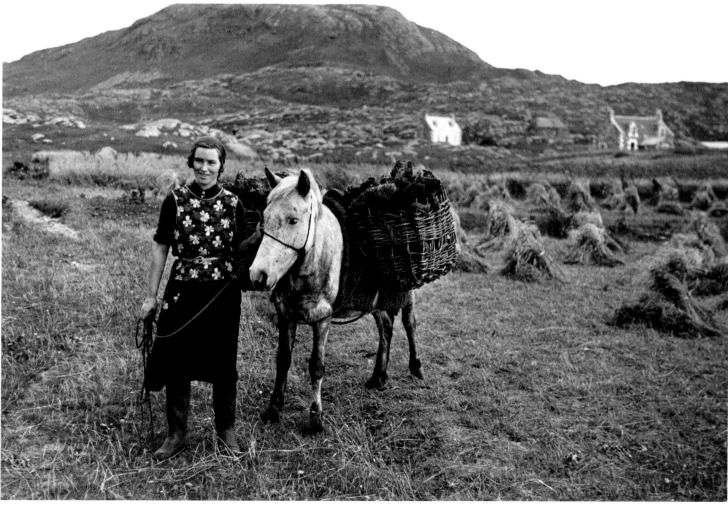

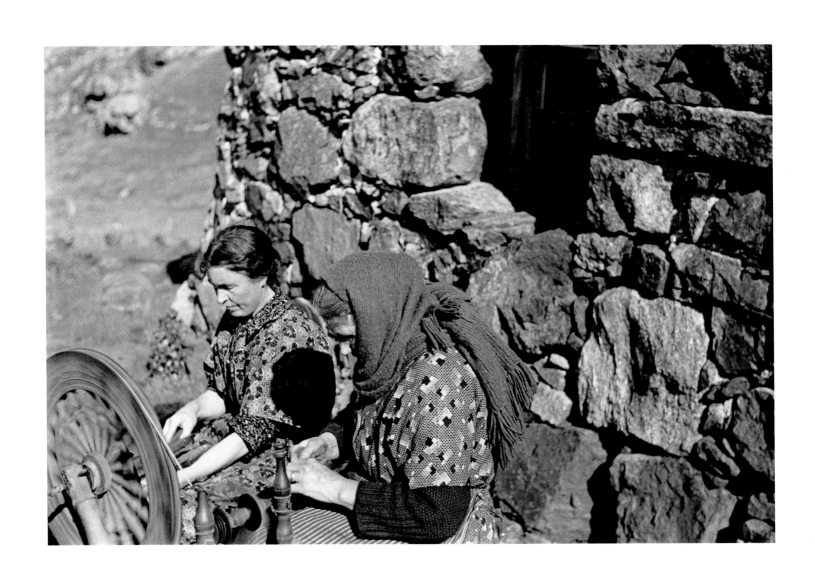

CARDING & SPINNING, *Eriskay, 1934*
(Left) Mrs Morag MacInnes and (right) Mrs Mary MacMillan.

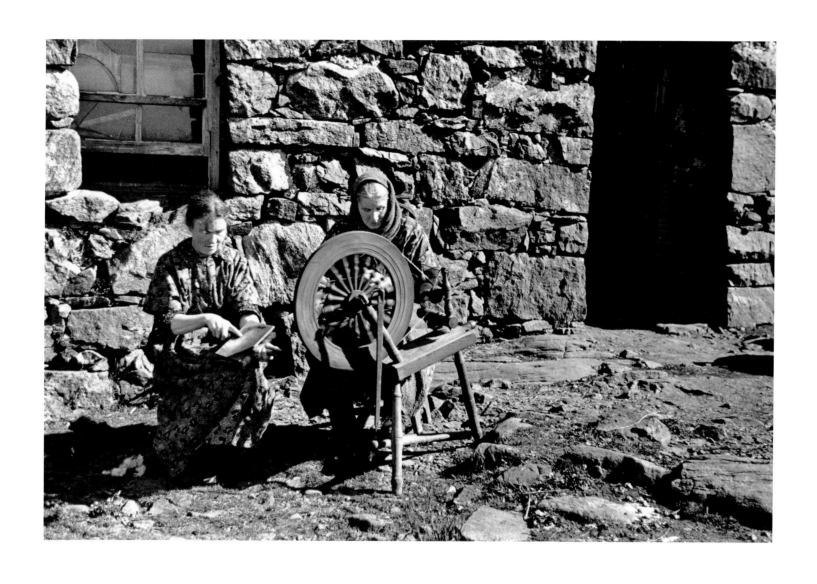

CARDING & SPINNING, *Eriskay, 1934*
(Left) Mrs Morag MacInnes and (right) Mrs Mary MacMillan.

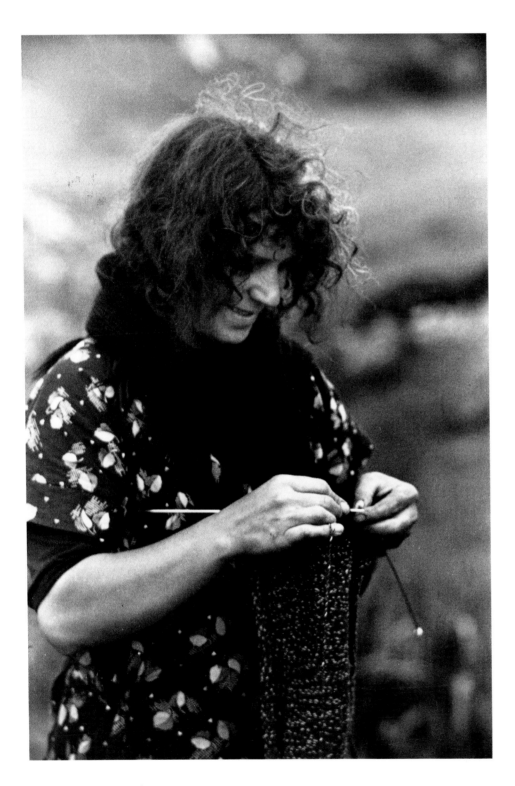

KNITTING, *Eriskay, 1934*

Peigi Mhoir 'ic Mhichael Eachainn.

 The photograph shows Kissling's ability to represent people as they were when engaged in their normal daily occupations. Women knitted constantly even when carrying creels of peat on their backs.

Hebrides 1934–1937

Whilst on Eriskay making his film, Kissling used his yacht to visit the other islands in the southern part of the Western Isles. Photographs from South Uist predominate in these pictures. Kissling returned to Eriskay and South Uist in 1935, 1936 and probably in 1937, but he was in New Zealand in 1938 and was interned in 1939. He showed his film in South Uist in 1935 and perhaps in the following years as well.

The names of those in the photographs are given in Gaelic where known, and otherwise in English if they were recorded by Kissling in his notes.

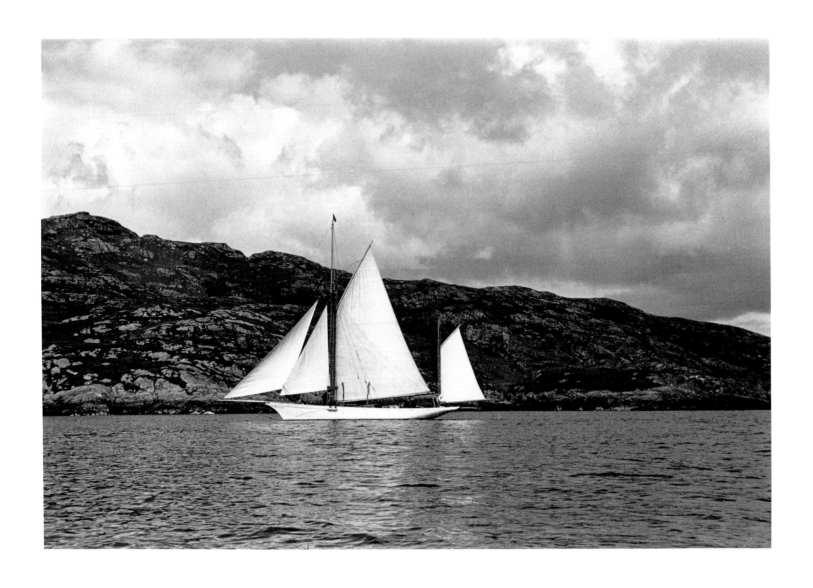

LOCHBOISDALE, *South Uist, 1934*

The *Elspeth* is pictured coming into Lochboisdale under full sail – she had a small crew and was skippered by 'The Skyeman' as he was known on Eriskay because he hailed from that island. He was engaged in Gourock with the boat.

SOUND OF BARRA
Light meadow (*machair*) land on Eriskay with Barra in the distance.

PEAT STACKS, *South Uist*

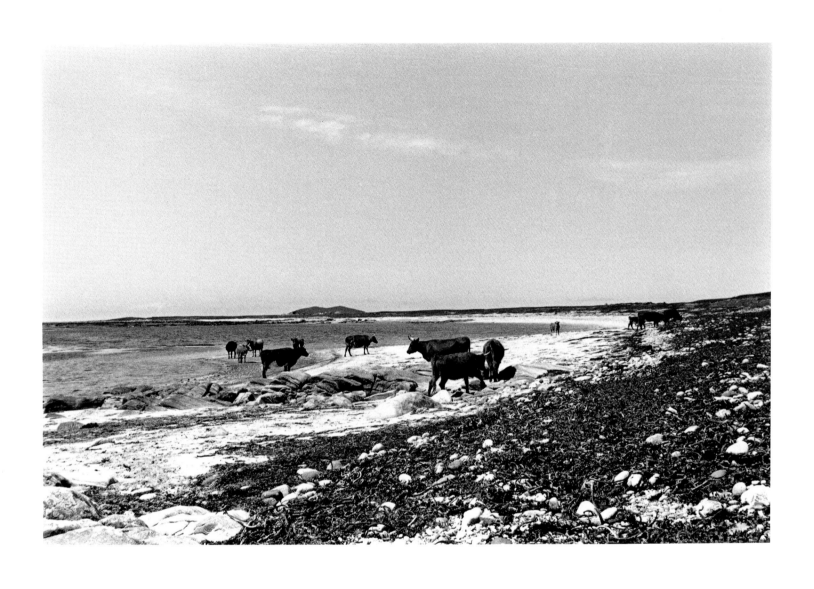

CATTLE, *South Uist, 1934*
This is an unusual photograph from Werner Kissling and is one of
his few landscapes without people or signs of human habitation.

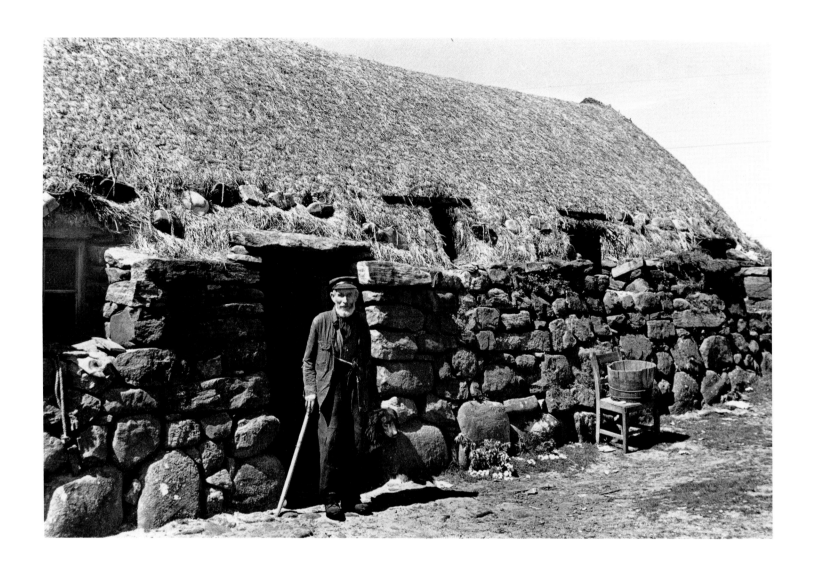

BLACK HOUSE (modified), *Polochar, South Uist, 1934*

Kissling writes: 'This house faces east, its doorways sheltered from the prevailing winds. The walls of stone and earth are about 6ft high throughout and $3^{1}/_{2}$ ft thick at the base, decreasing in thickness towards the top. As usual they have an inner and outer facing, built entirely of undressed stones of every size and shape, with a core of earth and turf but without mortar. There is no regularity in the masonry except perhaps round the doorway in the eastern long wall of the dwelling proper, the stones for which seem to have been carefully selected. A point of interest in the wall construction is that some, at least, of the stones in the outer facings are definitely set slanting downwards towards the outside. It has been impossible to discover whether this had been done on purpose, so as to shed rainwater from the roof which if placed as traditionally on the inner faces of the walls only, conducted all the water into the core of the walls.'

BLACK HOUSE (modified), *Polochar, South Uist, 1934*

Once again Kissling chooses as his subject the black house, but this time with atmospheric smoke, which must have been present in pungent quantities in each of the houses he visited. He notes on the index card for this picture: 'The largest of the windows has a kind of lintel stretching across the inner wall where the window-frame is placed. Clearly this type of house with its rounded thatched ends, in spite of being rather recently built and modified in certain respects, still retains the essential character of the old black house.'

DWELLING-HOUSE, *South Uist, 1934*
Mrs Sarah MacRae, son and daughter.

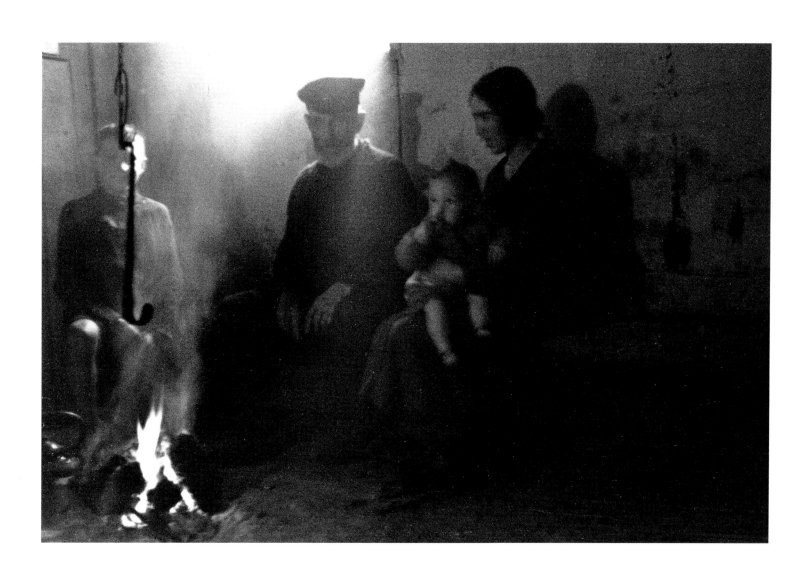

INTERIOR (Black House), *South Uist, 1934*
One of the best known of Kissling's studies, the use of natural light and shade gives a reality to the interior which lesser photographers were unable to record.

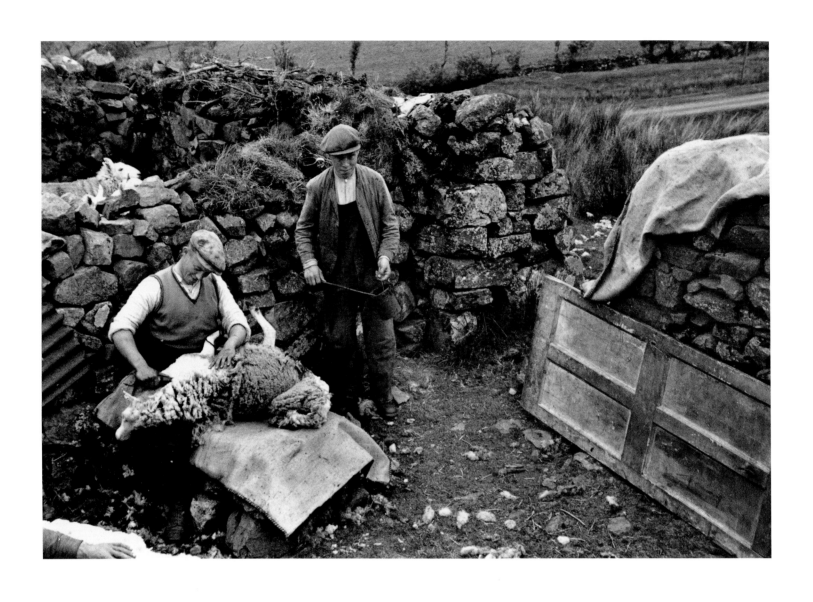

SHEARING, *Dunakillie, Skye, 1935*
Kissling visited Skye on a number of occasions but did little detailed photographic work. His interest in sheep-related crafts is again to the fore.

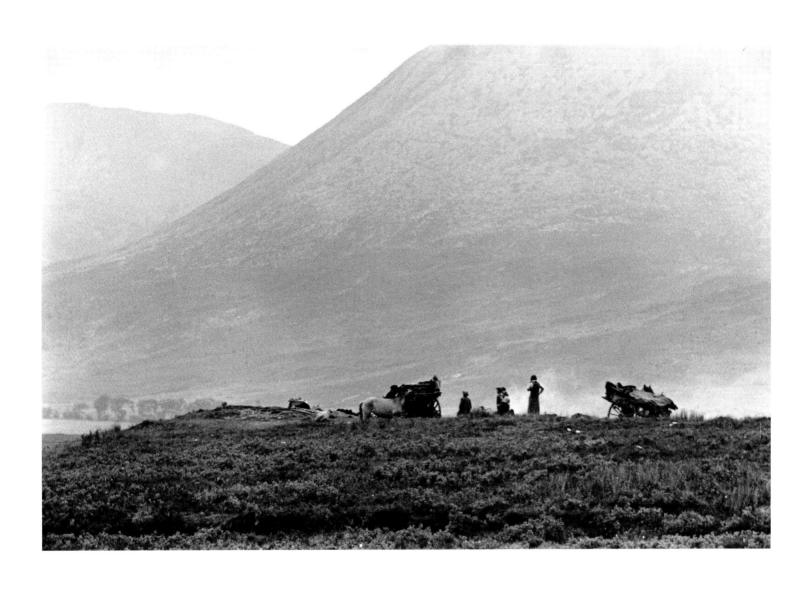

TINKERS' ENCAMPMENT, *Skye, 1935*
Sconser looking to Glenuig.

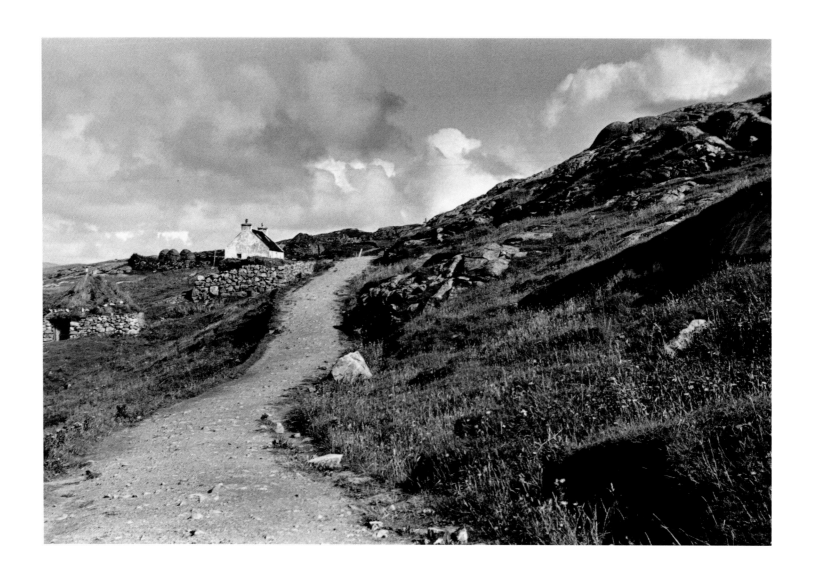

DWELLING-HOUSE, *Eriskay, 1936*

House built by the Board of Agriculture in 1920, roofed with corrugated iron.

 The road is 'Rathad Kissling', named after Werner Kissling by the inhabitants of Eriskay as the money to improve it came from the première of *A Poem of Remote Lives*, held at Londonderry House in London on 30 April 1935.

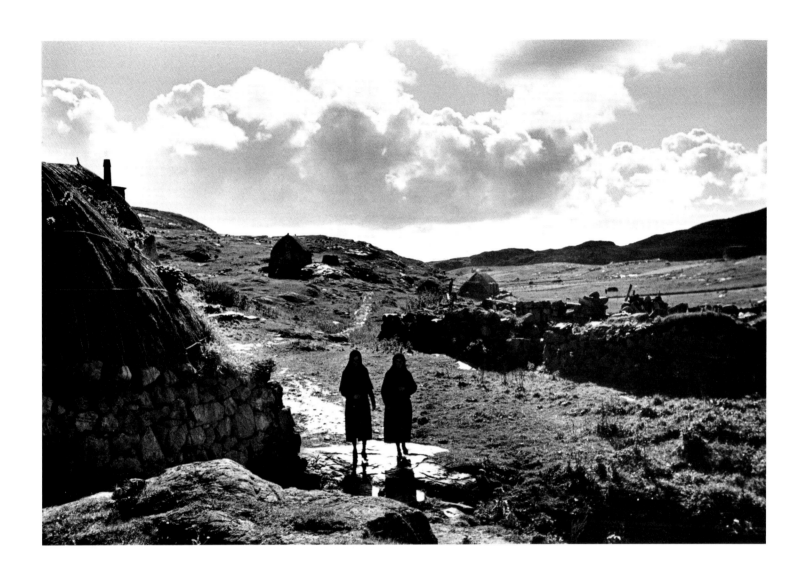

DWELLING-HOUSES, *Eriskay, 1936*

The photograph could be from anywhere in Europe at the beginning of the twentieth century.
Kissling's eye for composition makes it special.

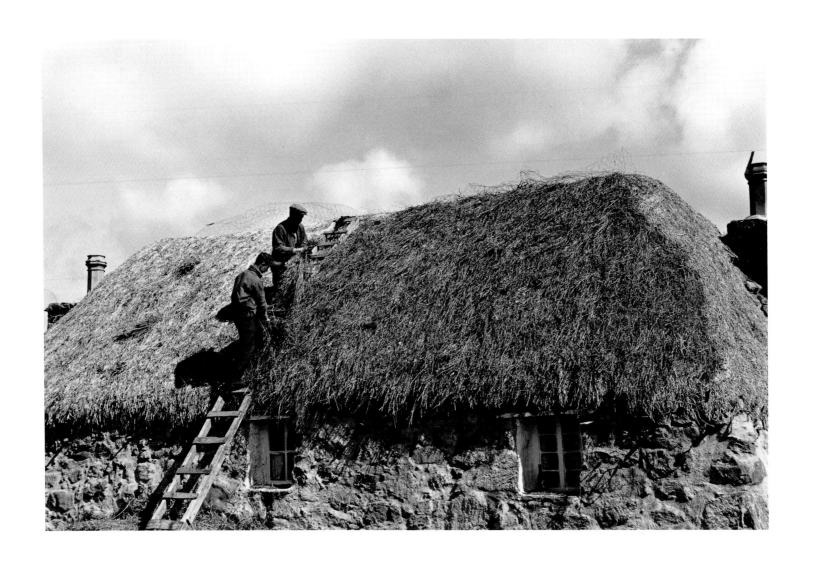

THATCHING, *Eriskay, 1936*

68 *A Different Country*

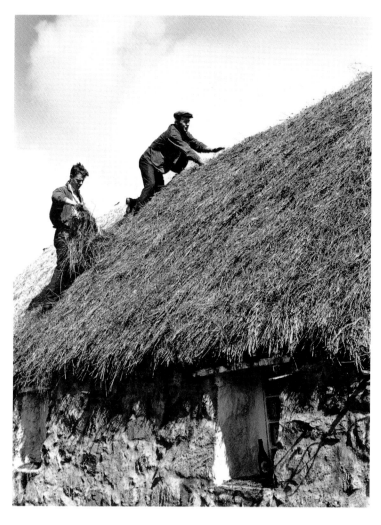
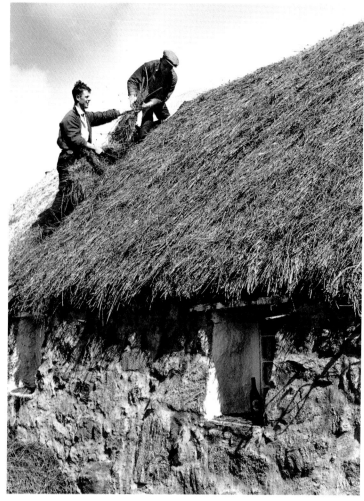

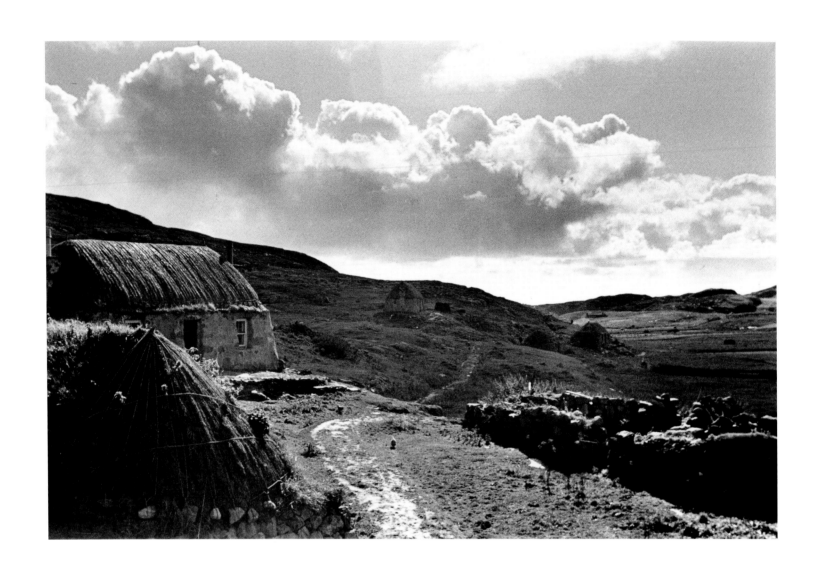

DWELLING-HOUSE, *Eriskay, 1936*

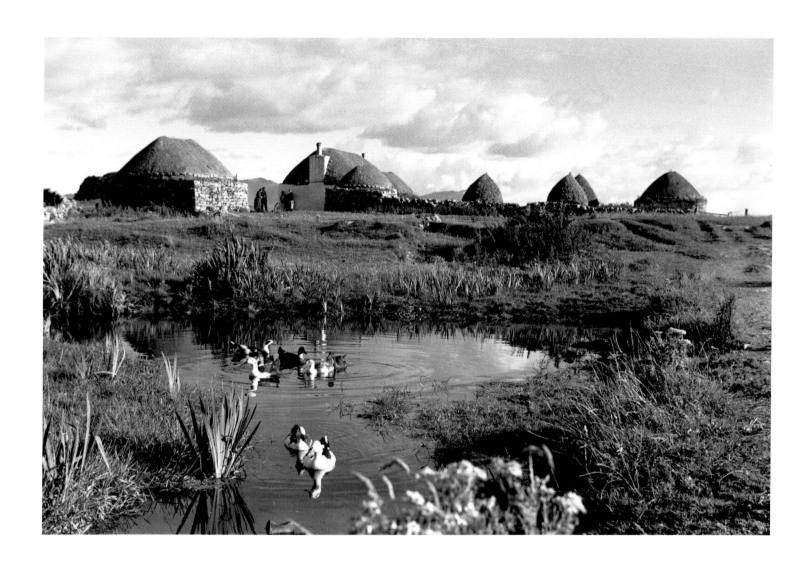

CROFT, *Iochdar, South Uist, 1936*

Kissling writes: 'The cottage shows how the crofter can best deal with each type of wall. In the white-washed house which has been mortared the roof is brought to the outer edges of the walls, whereas where the roofing covers only the inner walls as in the outbuilding, the dry-stone work is left. The croft is rather an exceptional one in that some attempt has been made to form a yard.' Iochdar, whilst regarded locally as one of the poorest places in Uist, maintained a traditional culture well into the late twentieth century.

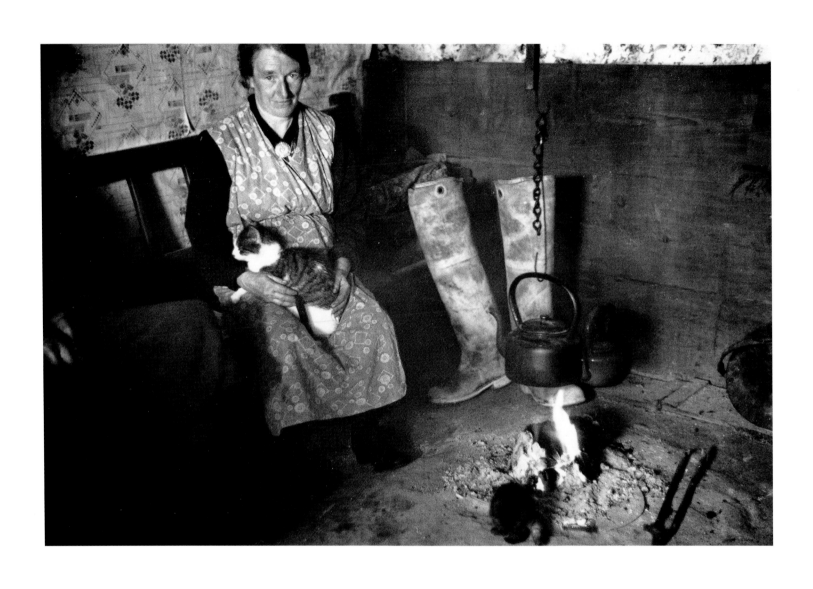

DWELLING-HOUSE (Interior), *Ardvachair, Iochdar, South Uist, 1936*
Kissling writes: 'Interior of black-house type. The open fire in the centre of the floor has been
maintained. Mrs Kate MacEchan occupies the house.'

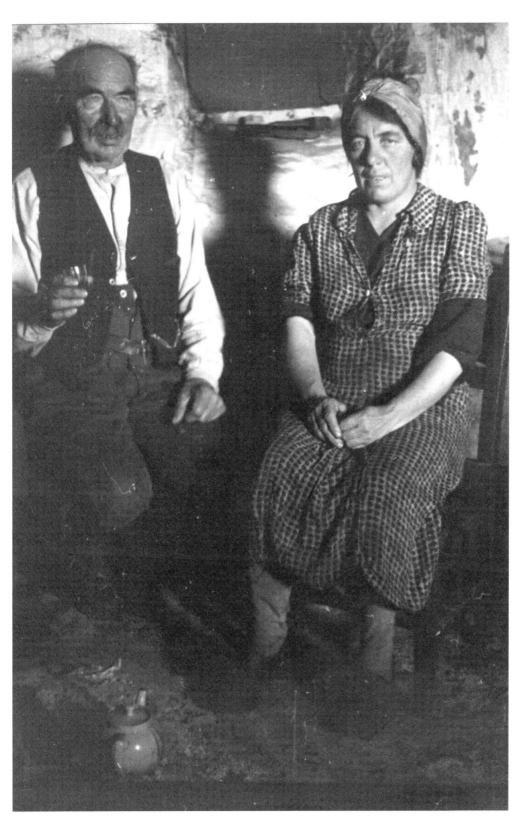

INTERIOR (Black House), *Ardvachair, South Uist, 1936*

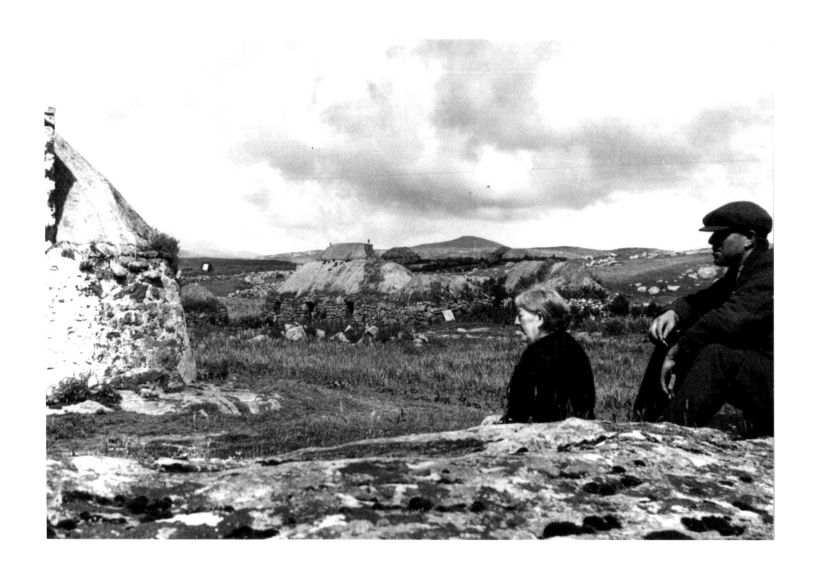

DWELLING-HOUSES, *Leth Mheadhoinneach Boisdale, South Uist, 1936*
Mary Smith's house; Mary Smith and Angus John Campbell in foreground.

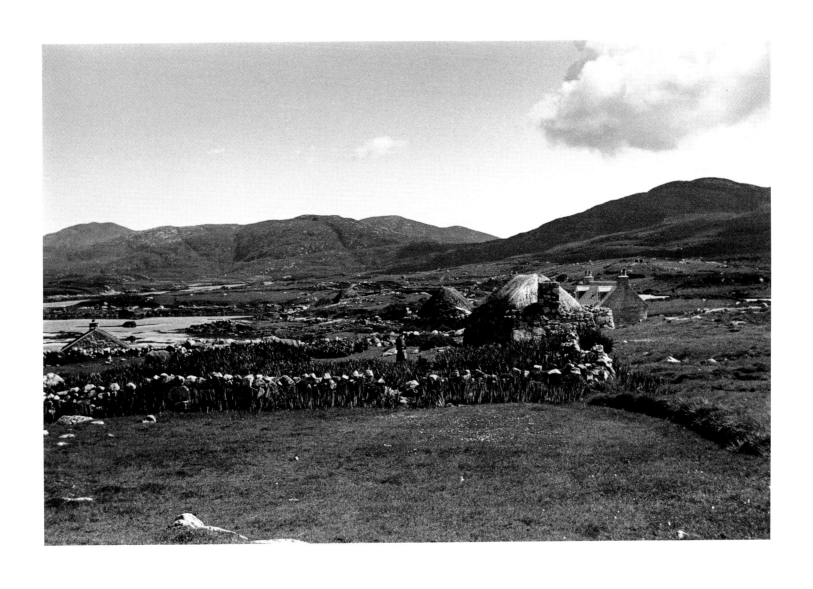

DWELLING-HOUSES, *Loch Eynort, South Uist, 1936*
Sheila MacMillan's house.

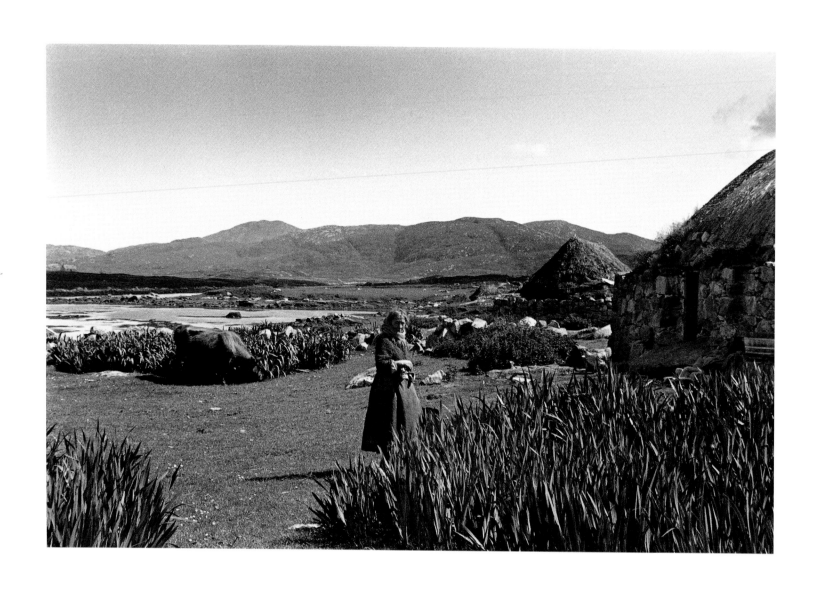

DWELLING-HOUSE, *Loch Eynort, South Uist, 1936*
The profusion of yellow flag iris, so common in Uist and so typical of the islands, can be seen in the foreground.

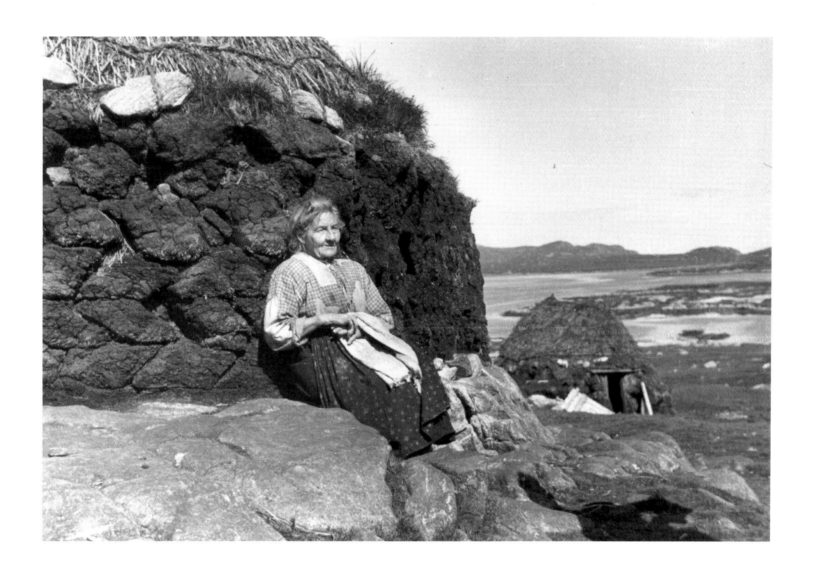

DWELLING-HOUSE, *Loch Eynort, South Uist, 1936*

Kissling's major academic study as an ethnologist was the Hebridean black house. The rounded end of the house shows one turf building technique, though by the time Kissling came to the islands this would have been very uncommon.

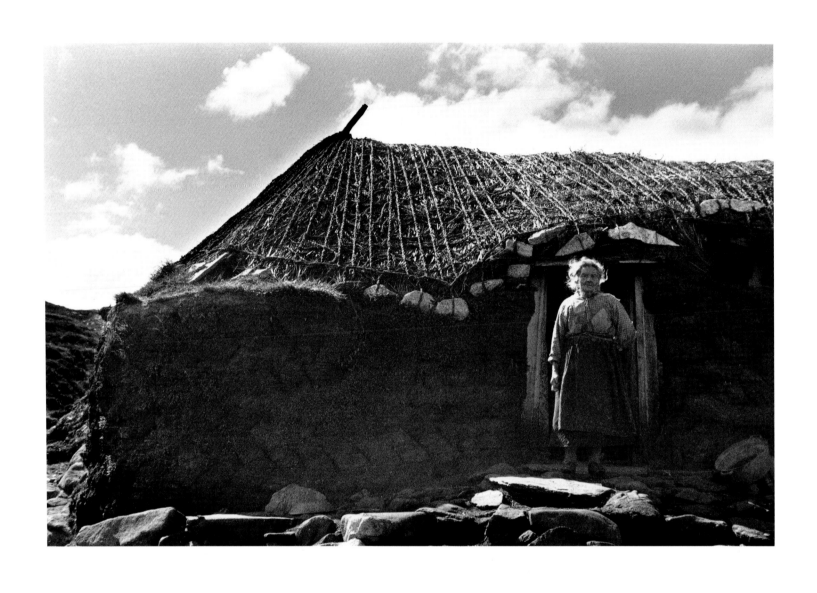

DWELLING-HOUSE, *Loch Eynort, South Uist, 1936*
Entrance to turf house.

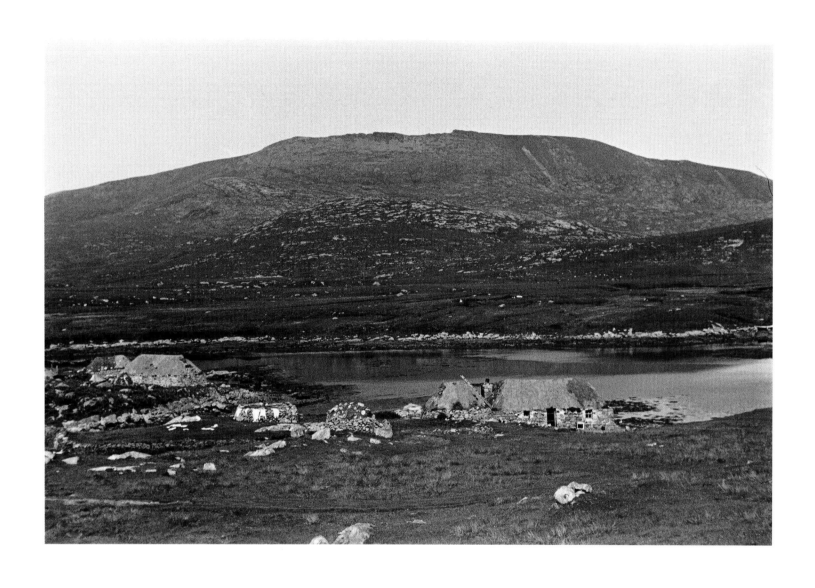

SOUTH UIST, *possibly Loch Eynort, 1936*

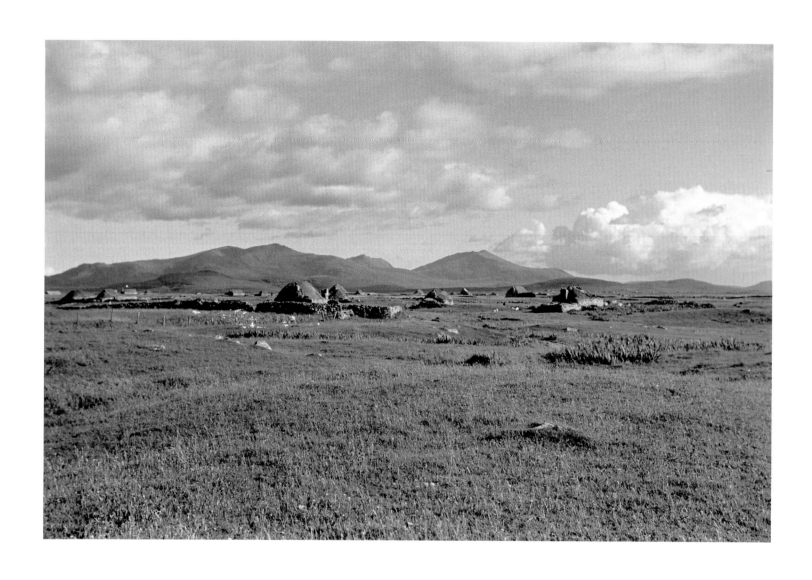

POLOCHAR, *South Uist, 1936*

Polochar is at the very bottom of the chain of islands that run north to Newton and Berneray. An inn there used to be the base of the ferry to Barra and there are local stories of Compton Mackenzie and Kissling drinking in the bar.

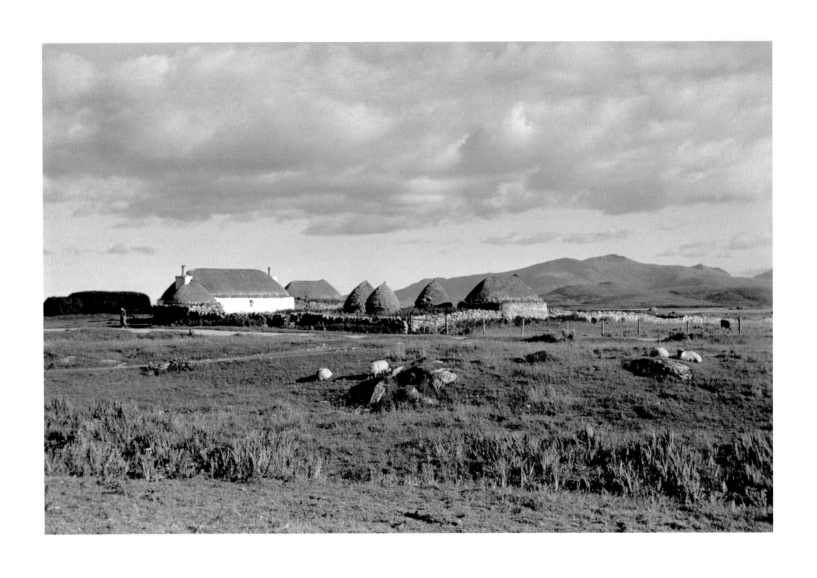

STEADING, *Polochar, South Uist, 1936*

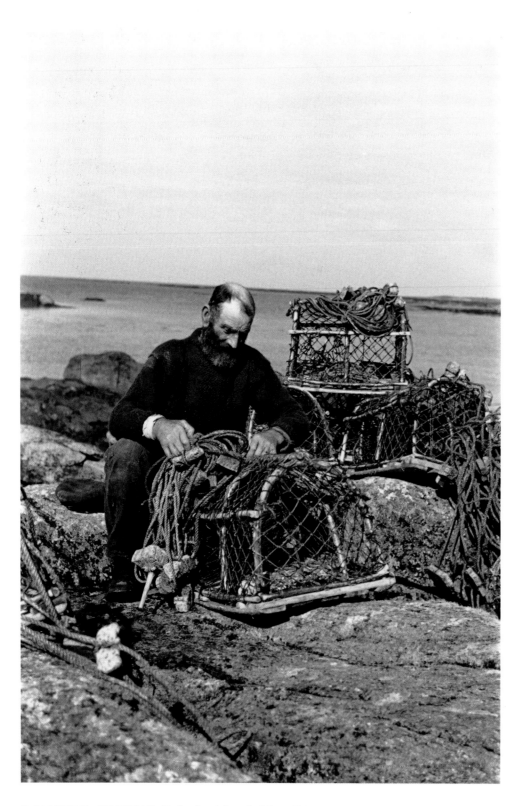

LOBSTER CREELS, *Polochar, South Uist, 1936*
These are net-creels, rounded at the top with a flat rectangular bottom. The rods used are of hazel.

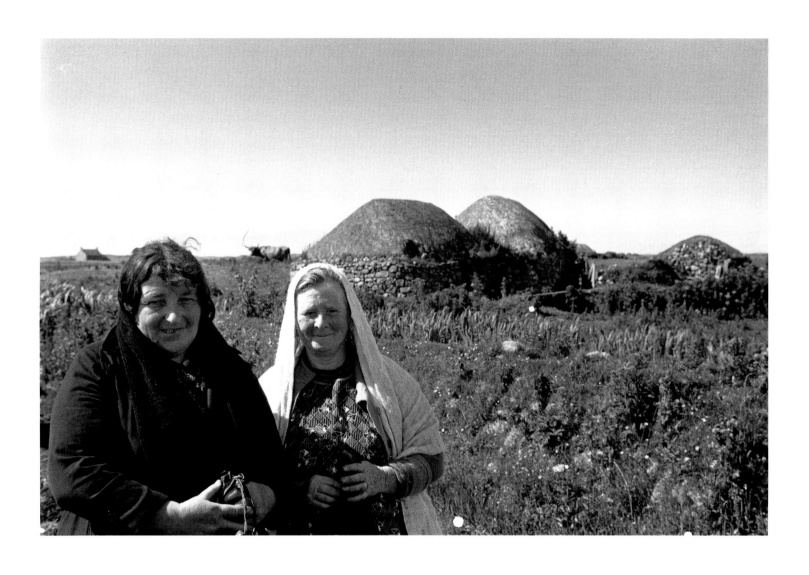

OUT-BUILDINGS, *Kilphedar, South Uist, 1936*

Mrs R. Maclellan and Mrs N. Morrison.

 Again, this is a photograph that could come from elsewhere in Europe one hundred years ago.
Even the clothing is traditional.

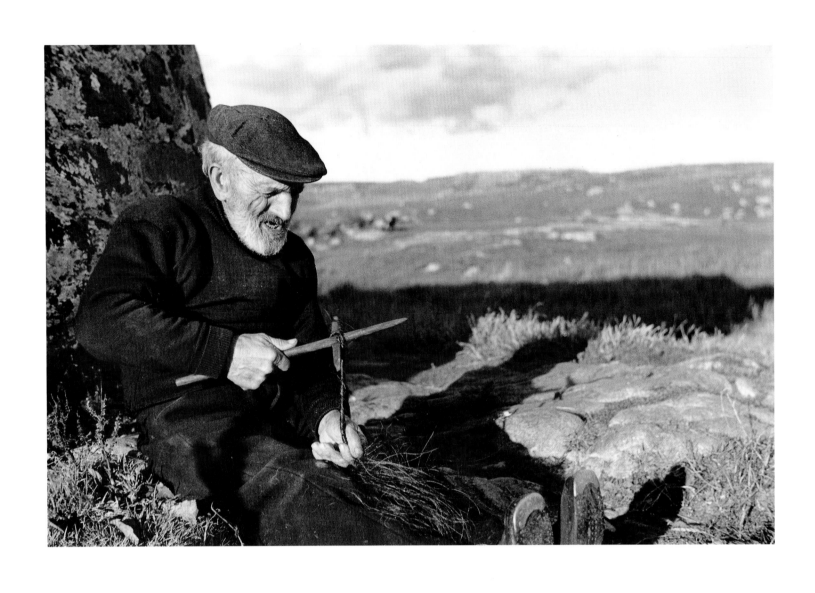

ROPE-MAKING, HORSEHAIR, *Lochboisdale, South Uist, 1936*

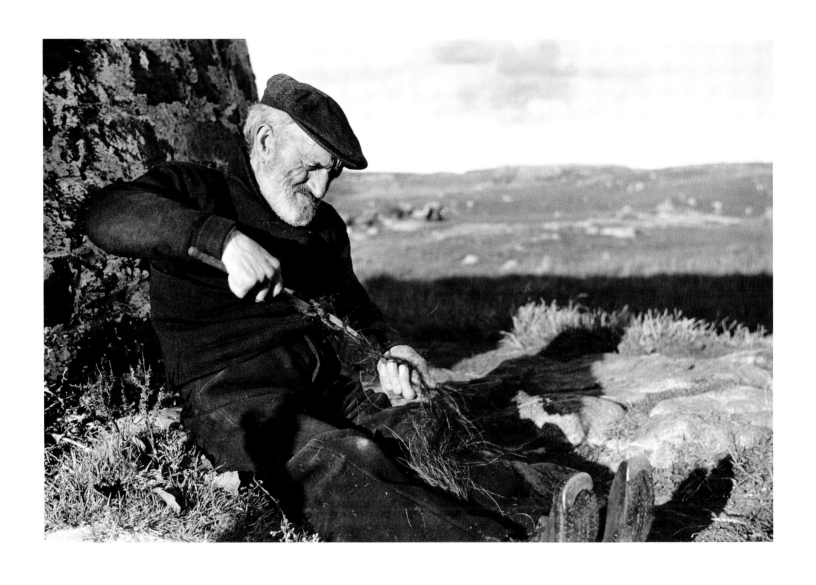

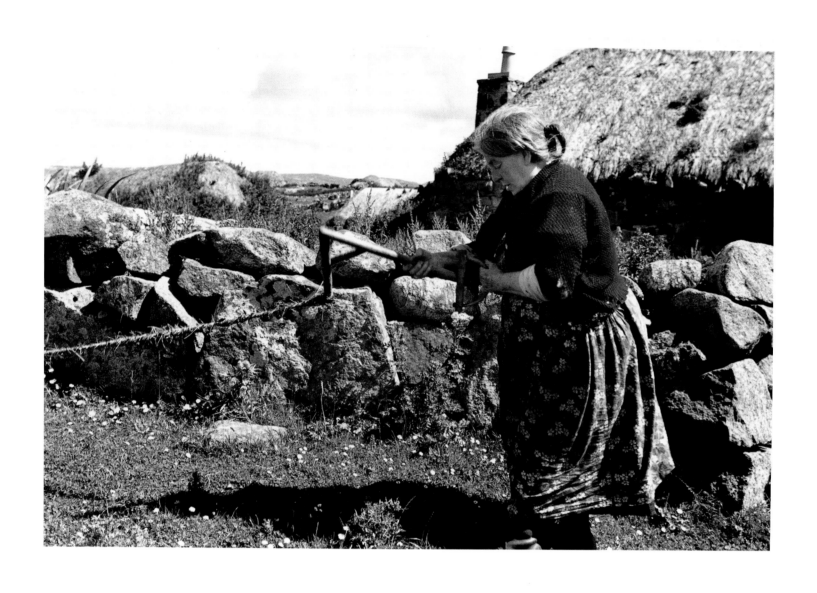

HAY ROPE-MAKING, *South Boisdale, South Uist, 1936*
Kissling recorded many crafts that have now disappeared, and observed them in many different
places. This photograph shows the making of hay-rope with a simple wooden twister (*corthsagan*).

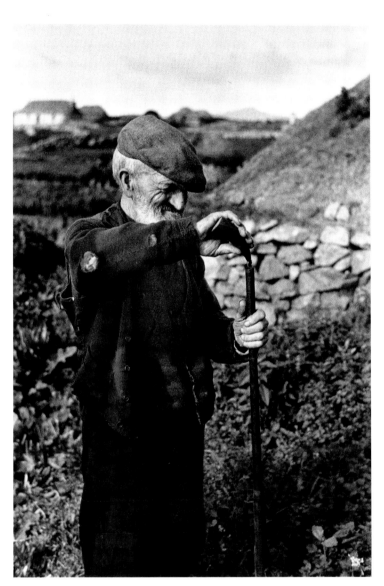
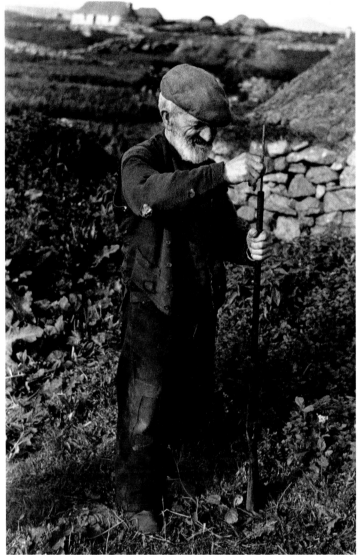

POWDER-HORN, *South Boisdale, South Uist, 1937*
Use of powder horn and stumper for loading gun.

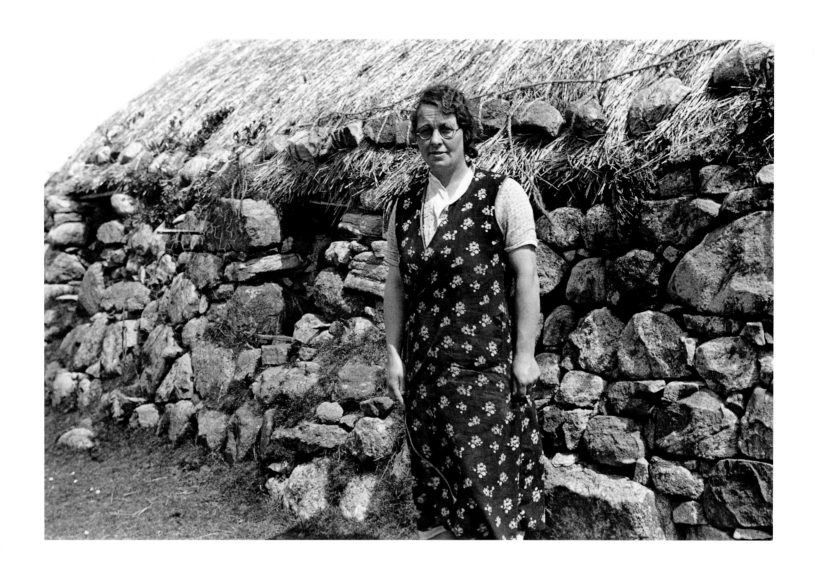

DWELLING-HOUSE, *Howbeg, South Uist, 1937*

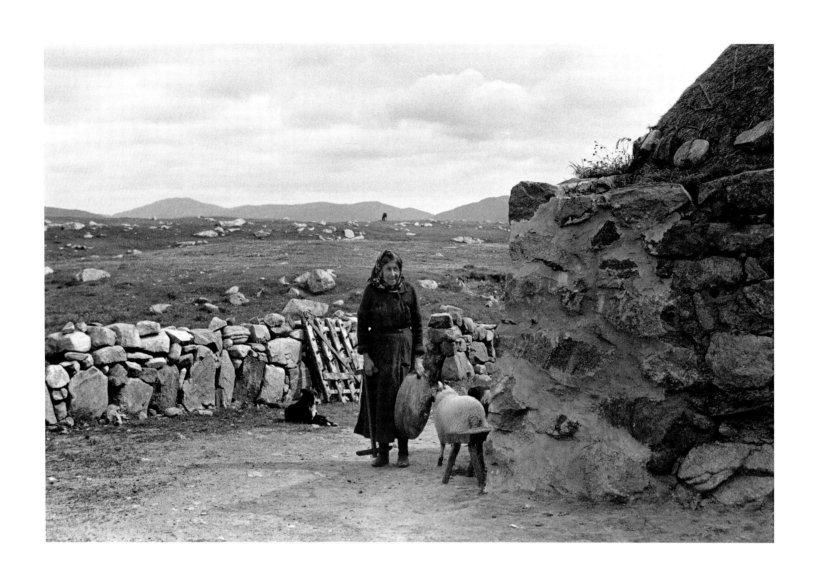

GABLE, *Howbeg, South Uist, 1937*
Annan Néill Mhóir.

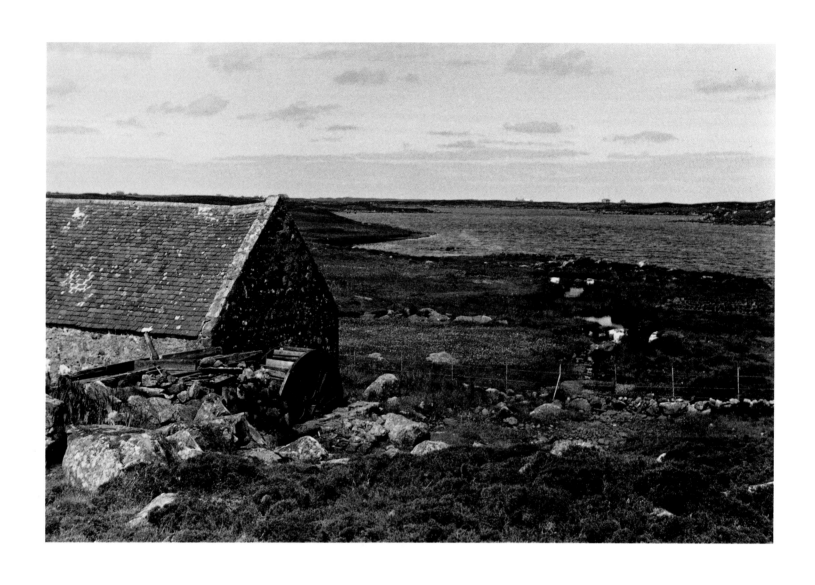

WATERMILL, *South Uist, 1937*

Post War Hebrides

When he was released from internment, Kissling was forbidden to return to the Western Isles, which was a security zone during the war, and was not able to resume his Hebridean photography until 1947. Thereafter, he visited each year until the mid 1950s, staying in the same room in the Lochboisdale Hotel and travelling throughout the Western Isles. His worsening financial position seems to have put an end to these trips – there are certainly no Western Isles photographs in any of the known collections that date from after the 1950s.

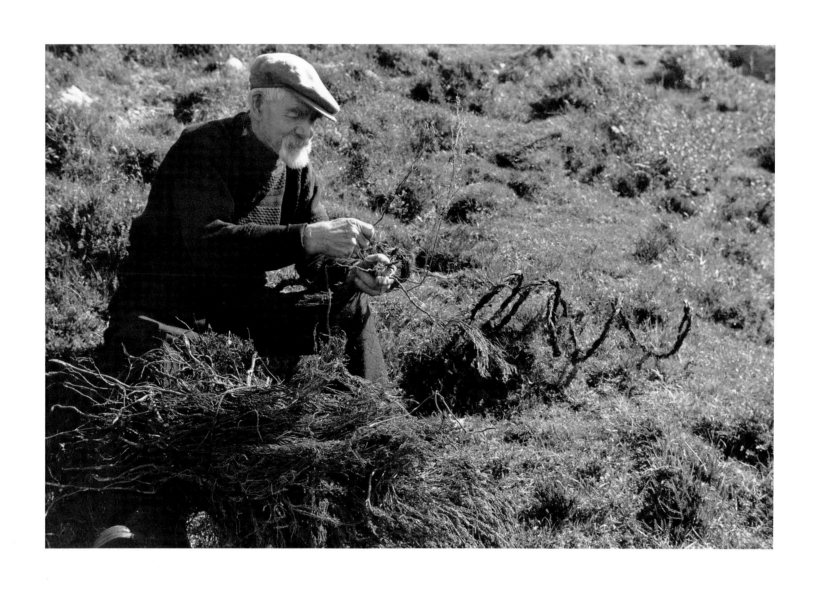

HEATHER ROPE-MAKING, *South Lochboisdale, South Uist, 1947*
Twisting heather into rope by hand.

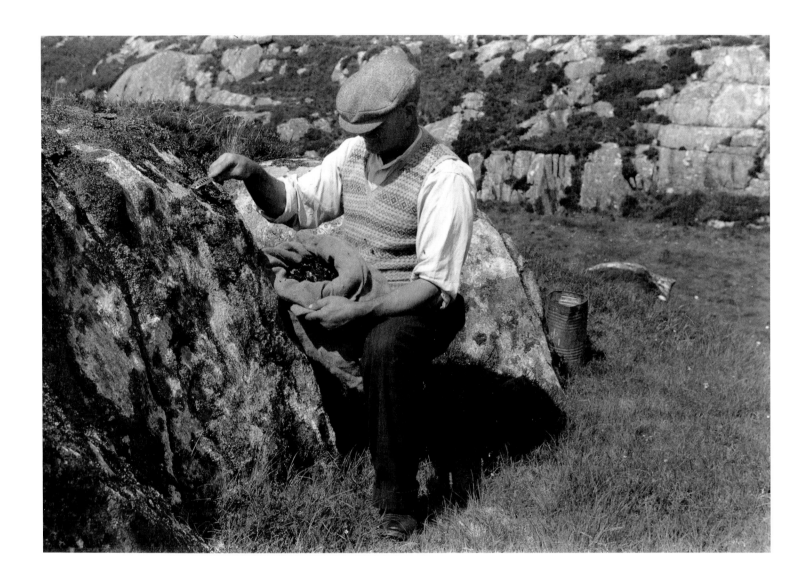

COLLECTING CROTAL, *Loch Carnan, South Uist*
Kissling's film includes a section on *crotal* gathering and recalls an Eriskay story of the man who stole *crotal* from a site that belonged to someone else – and the consequences he suffered, including being shunned by the community. The reliance on producing material with distinctive dyes was so strong in some places that the theft of colours was the equivalent of stealing patents.

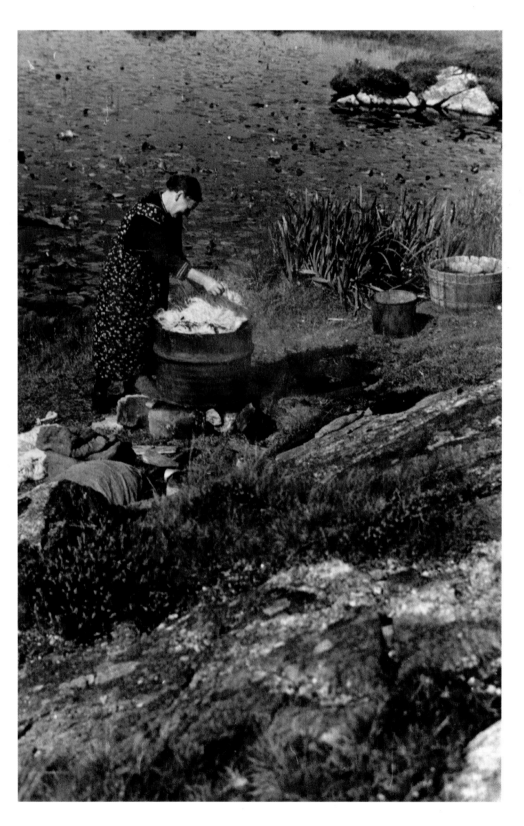

DYEING WOOL, *Loch Carnan, South Uist*
Mrs Catherine MacInnes boiling wool and *crotal* in alternative layers to obtain a good dye.

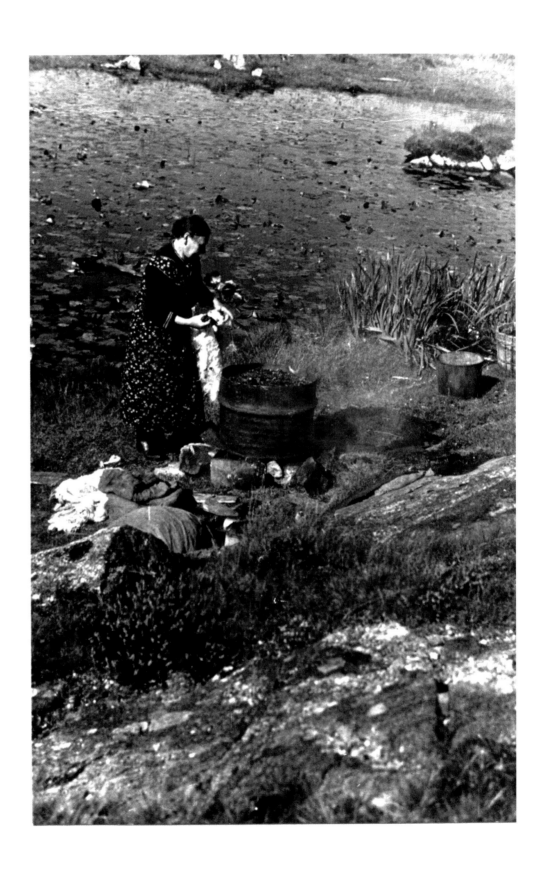

PICKING BOG-MYRTLE, *Garrynamonie, South Uist, 1947*
Miss Kate Maclean picking bog-myrtle for wool dyeing. Bog myrtle was also reputedly good for
driving off midges and a sprig of it was often put behind horses' ears for that purpose.

HARBOUR HOUSES, *Lochboisdale, South Uist, 1950*
A very unusual study by Kissling in that it shows a small town without any people. The view is from the pier and to the right, outside the picture, lies the Lochboisdale Hotel where Kissling stayed each year in the same room when visiting the islands.

HARBOUR HOUSES, *Lochboisdale, South Uist, 1950*
The dependence of the islands on freight of all sorts can be seen in the goods gathered on the pier for
dispersal to other parts of South Uist.

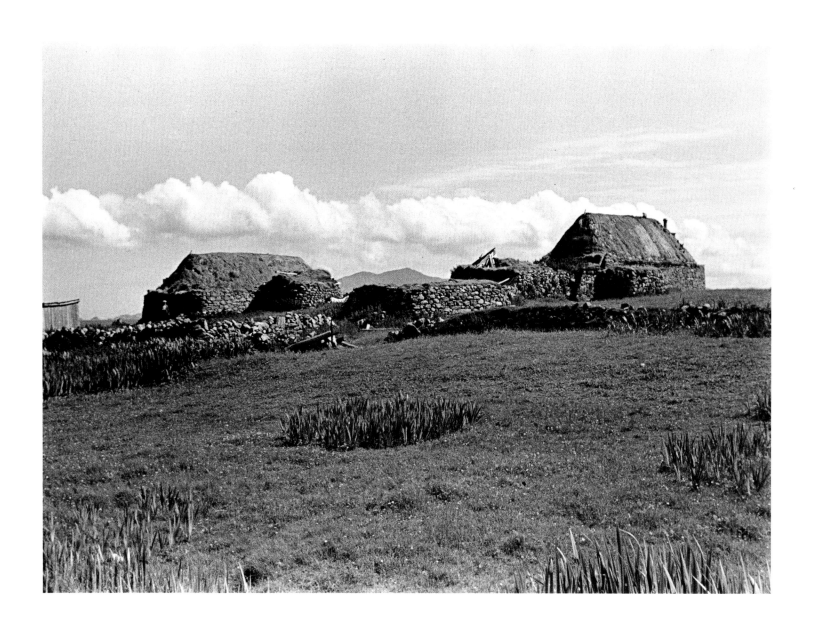

BLACK HOUSE ('tigh dubh'), *Ardvachair, South Uist, 1951*

CARDING, *Ardvachair, South Uist, 1953*

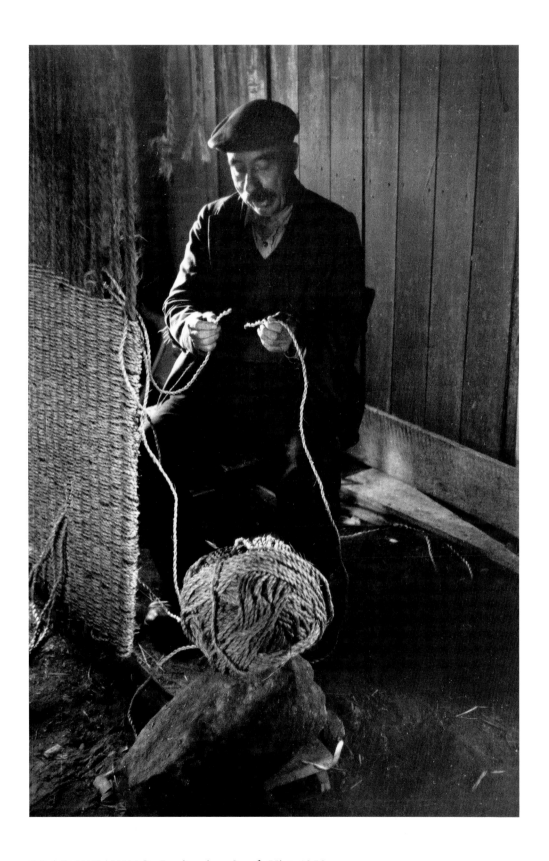

PLAD-WEAVING, *Peninerine, South Uist, 1953*

PLAD-WEAVING, *Peninerine, South Uist, 1953*
Again an atmospheric use of natural light makes this ethnological photograph come alive.

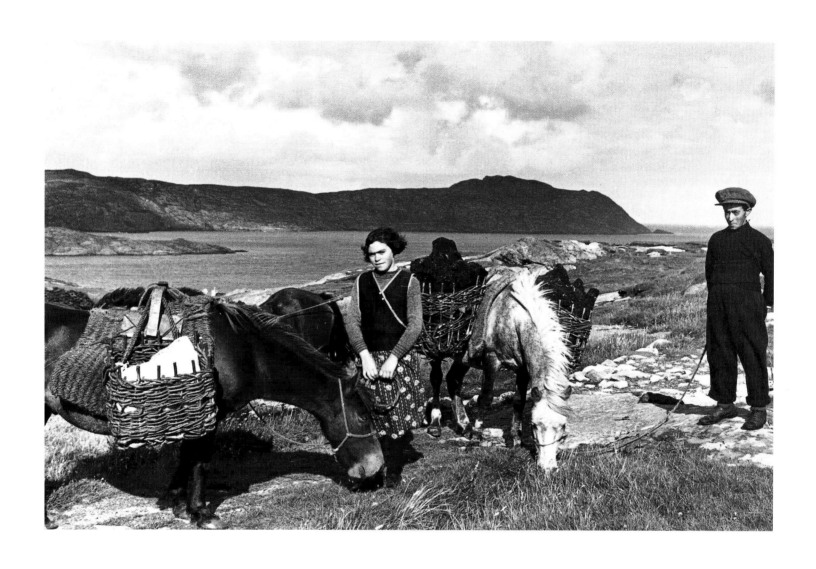

Ponies with *plads*, *Eriskay, 1953*

This picture was given by Werner to his friends Andrew and Rosalind Croft just before he died.
The back of the photograph bears a dedication in his spidery late handwriting, 'Rosalind and Andrew
with love from Werner. *Plad* in position Eriskay 1953.'

HORSE, *Peninerine, South Uist, 1953*
The *plad* in position along the horse's back.

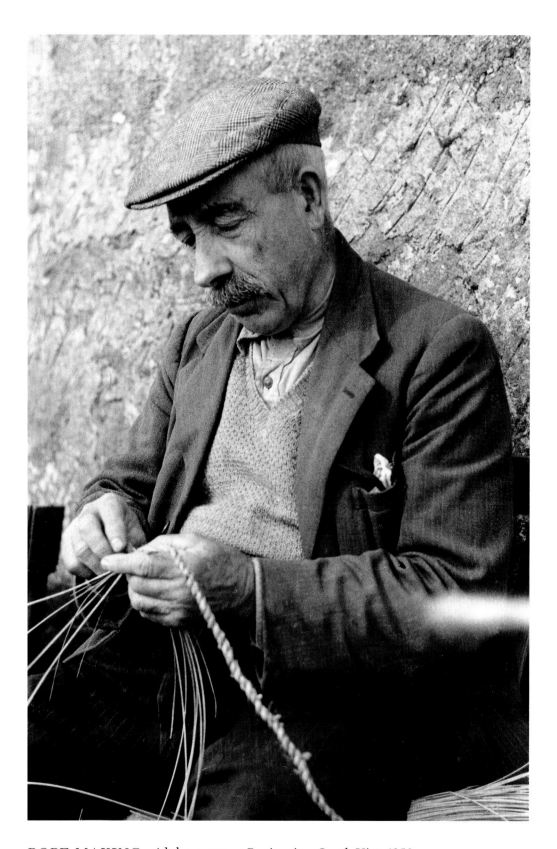

ROPE-MAKING with bent-grass, *Peninerine, South Uist, 1953*

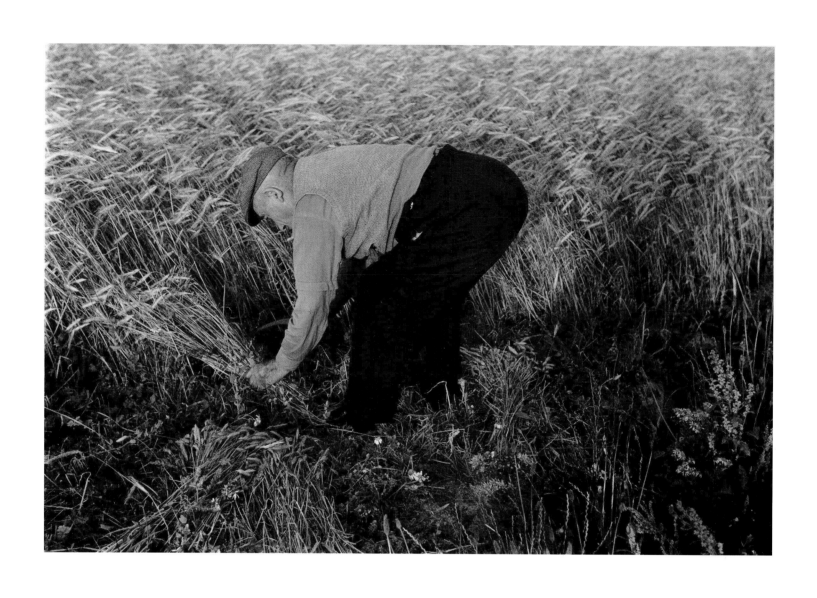

REAPING CORN, *Peninerine, South Uist, 1953*
Cutting corn, a handful at a time.

The Borders, Dumfries and Galloway

Kissling knew the Scottish Borders and Dumfries and Galloway well from the 1930s onwards having first travelled through them during his trips – by car – to the Western Isles. He came to live in Melrose in 1952 and took an extensive range of photographs in the Borders and in Dumfries and Galloway from that time onwards. His output rose as he became short of money and he sold ethnological photographs of the area during the 1950s and 60s, usually to university archives. He also collected artefacts for Dumfries Museum and whilst he devoted less time to photography towards the end of his life – he eventually sold his Leica – he continued to organise and catalogue artefacts until shortly before his death in 1988. There were two retrospective exhibitions of his photography in Dumfries during his last decade.

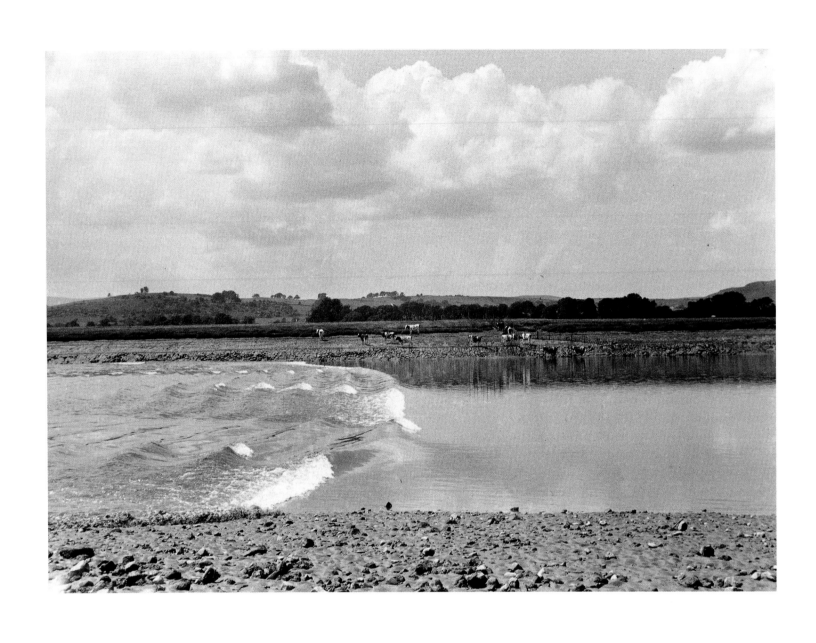

TIDAL BORE, *River Nith, Glencaple, Dumfriesshire, 1954*
Start of the floodtide. The bore of a 20ft spring tide running up the River Nith at Glencaple. This is
one of Kissling's earliest pictures from Dumfriesshire

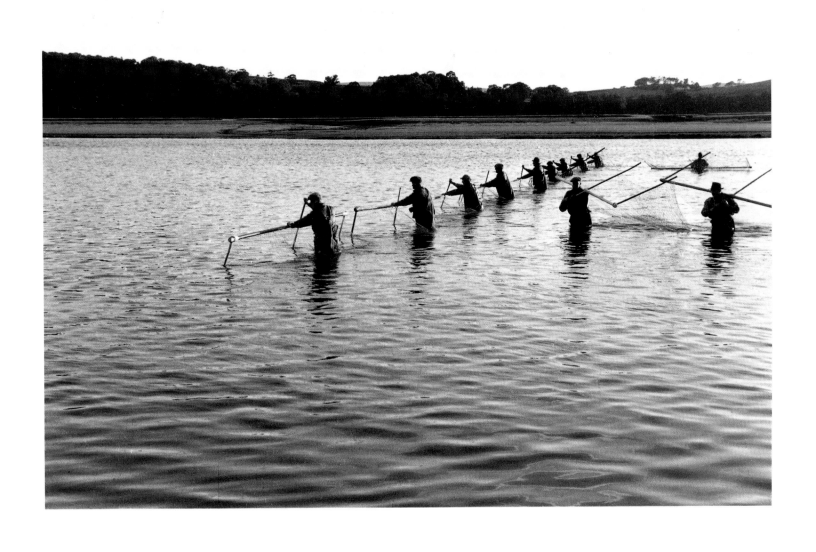

HAAF-NET FISHERS, *River Nith, Solway Estuary, Dumfriesshire, 1955*

Kissling took an extensive series of pictures, on more than one occasion, of haaf-net fishing in the Nith. This one shows the men changing over to the *shal* and cleaning the nets.

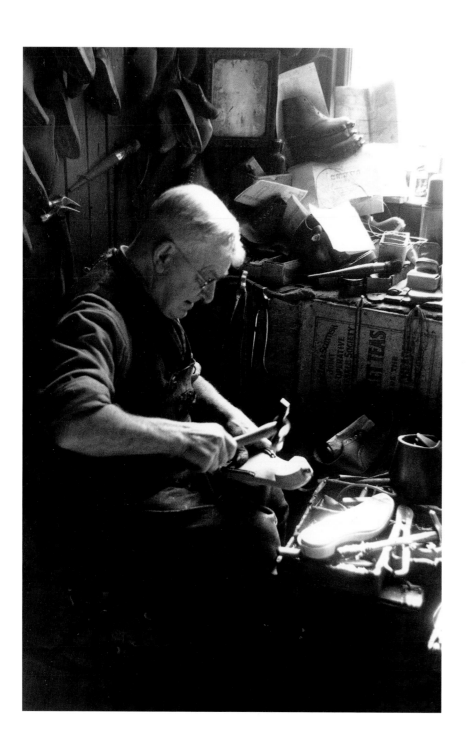

CLOGMAKER, *Dumfries, 1956*

Kissling was still resident in Melrose when he took this picture but it became one of the many that he contributed to the Dumfries Museum. Later on, when living in Dumfries, he also collected traditional implements and tools for the museum's collection. His note on the photograph reads, 'fixing an iron "caulker"' to the wooden soles. Note the pair of clogs in the background and the leather uppers hanging on the wall. The uppers are fastened by laces or a metal clasp. Generally women's clogs have the clasp fastening and the men's have laces.

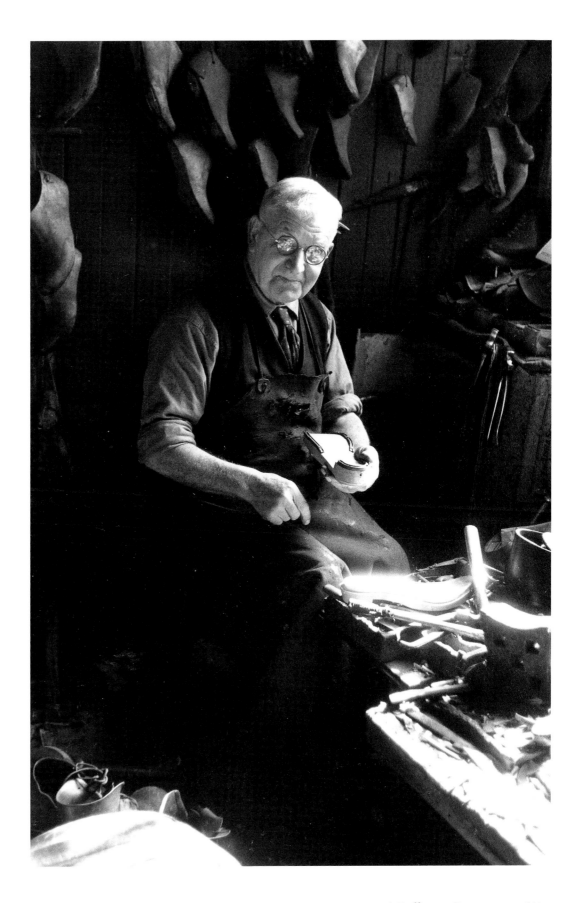

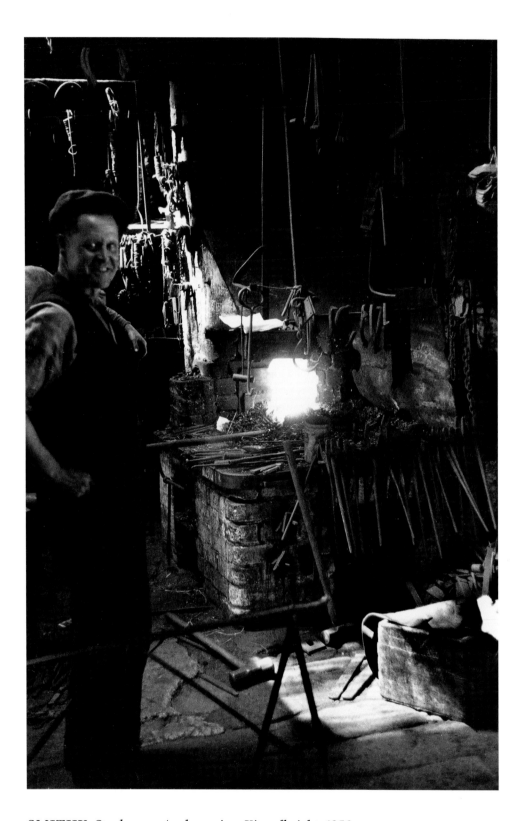

SMITHY, *Stockmoss, Auchencairn, Kircudbright, 1956*
The blacksmith, Mr MacGill. Again this is one of a series, this time featuring a father and son at work in their blacksmith's shop.

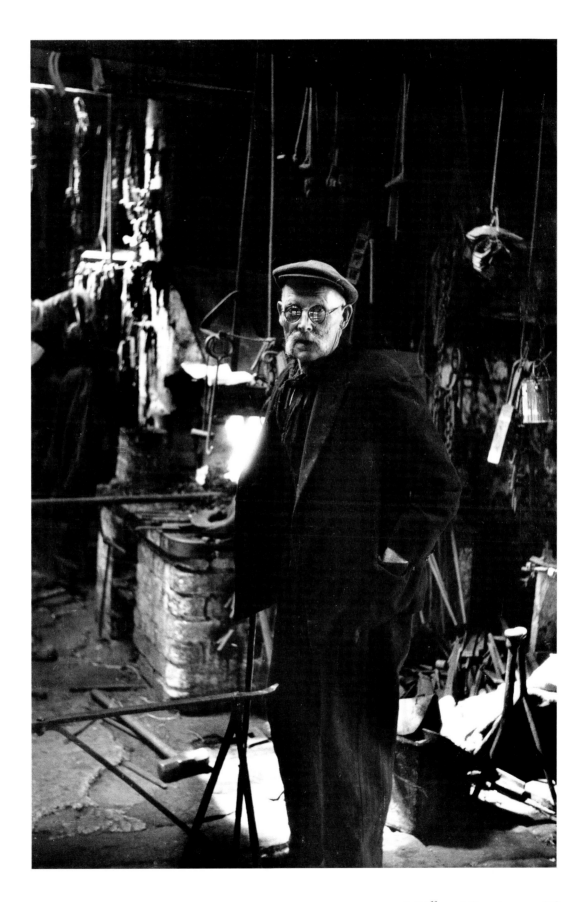

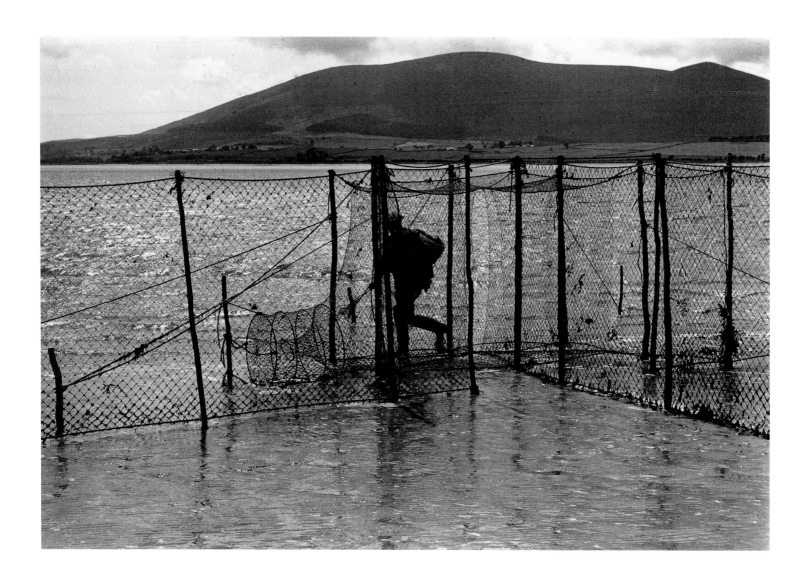

PAIDLE NET, *Estuary of Nith, Solway, Dumfriesshire, 1956*

Kissling's note on this photograph is a good illustration of the way in which much of his work was designed to allow an understanding of the process – in some detail – that we see, as well as encouraging a wider appreciation of the people involved. He writes: 'The position of the flounder net is on a channel bank with the head reaching over the top of the bank at a point where the fish, coming over the bank into deep water, would drop against one of the leading arms and find their way into the "pocket".

'The pocket may be fished, covered or not. The cover at the top of it, formerly only a sort of fringe or "fly", prevents the flounders floating out. It is today more important since the height of the paidle net is kept appreciably lower than it used to be when the nets were put up for the purpose of catching fish of the salmon kind as well. The average height of the paidle net today is about five feet; the pocket is about eight feet long by four and a half feet broad.

'The netting, formerly made of Russian hemp, a strong material sufficient to stop a running fish, is today much lighter, generally of cotton twine, seven-and-a-half-inch meshes.'

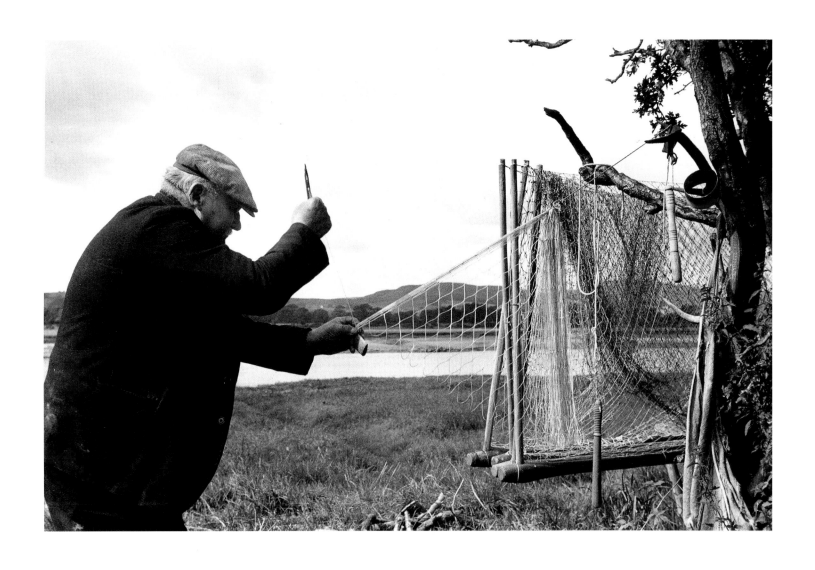

HAAF-NET KNITTING, *Glencaple, Dumfriesshire, 1956*

This photograph, while appearing staged, is actually a sharp and natural shot taken 'on the fly'.
Kissling comments: 'Haaf-net knitting is a dying art. Machine-made nets, however, are expensive and
don't last more than half a season. Retired fisherman, Bob Clarke, who always used to knit his own
net, today sells hand-made nets that keep him busy during the season.'

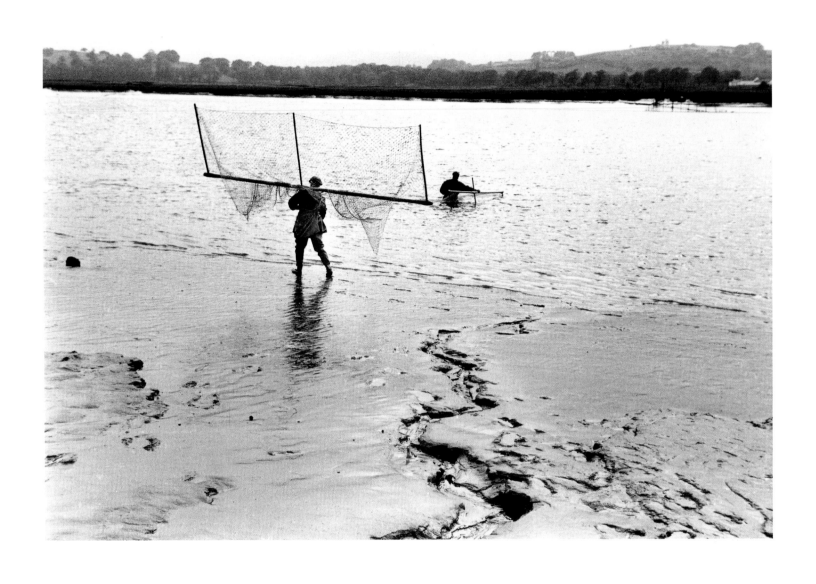

HAAF-NET FISHING, *Glencaple, Dumfriesshire, 1957*
The muddy nature of the Solway estuary can be clearly seen in this photograph, as can netting taking
place on the other side of the river.

PIER, *Glencaple, Dumfriesshire, 1957*
The mooring posts exist for using the river at exceptionally high water.

WATERMILL, *Gribton, Dumfriesshire, 1957*
This is an unusual Kissling photograph, which fits into the same small category as those of Lochboisdale pier earlier in the book, in that it is a landscape with buildings whose effect comes from composition rather than from composition plus action, which is the usual Kissling style.

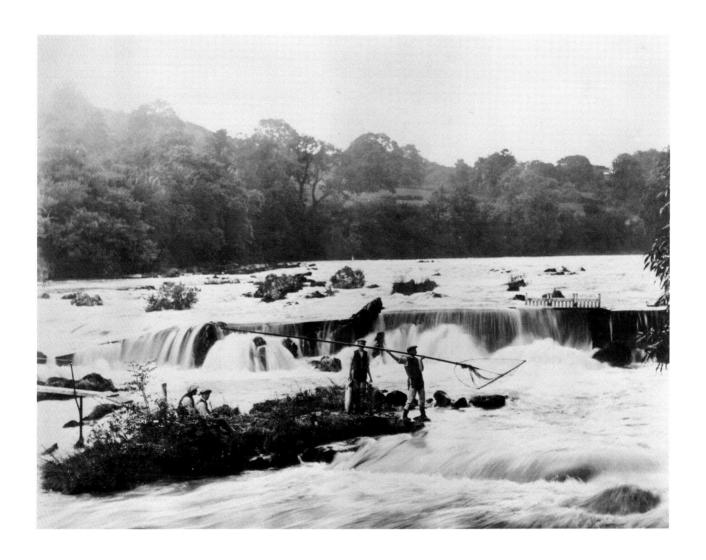

THE FLINGING OF A SHOULDER-NET, *River Dee, Kirkcudbright, probably early twentieth century*

These two photographs were donated by Kissling to the School of Scottish Studies archive in 1956. A great collector of artefacts, he clearly also collected photographs on occasion. Kissling provided the accompanying note: 'On a stretch of the Solway Dee, near St Mary's Isle, until recently a shoulder-net was used for netting salmon. The following information is taken from H. V. Morton, 1933, who had accompanied the salmon netters on a night's fishing at a time when this form of salmon "poaching" was still a legal operation, the right being granted by the Crown. The local legend was that it descended from Franciscan monks of the thirteenth-century.

'With his three companions he was on an island in the centre of the river.

All round us were white tufts where the water cascaded over the submerged rocks. The net-thrower prepared to fish. A grooved wooden implement was strapped on his right shoulder. He took a twenty-foot pole, at the end of which was a big net. He swung it in the air, poised it above him in the manner of a javelin thrower and cast it from him into the torrent. There was so little room on the island that we had to lie flat. . . to escape the swing of the pole. It was exciting to see the fisher rhythmically poising, flinging, then placing the great pole on the wooden shoulder groove and bringing in the net with a quick hand-over-hand movement.

['Preparing to fling the net', H. V. Morton, *In Scotland Again*, 1933]

'When a salmon was caught, a man leapt on it and hit it with a mallet.'

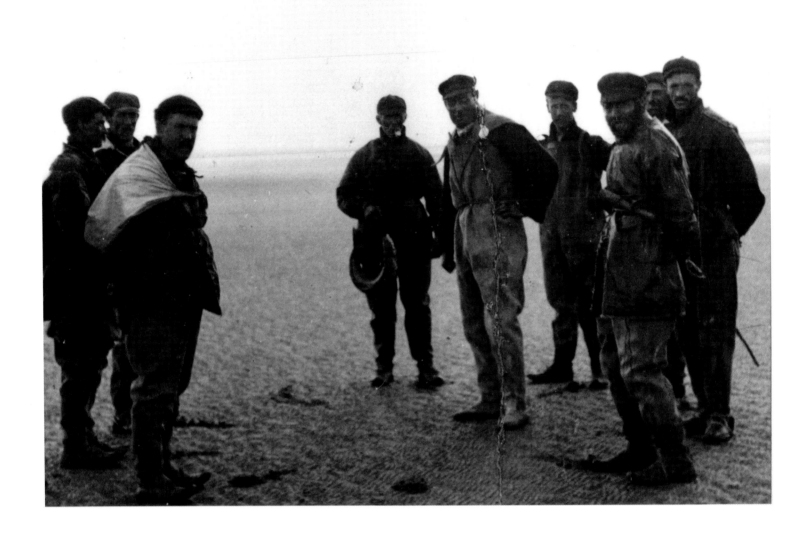

CASTING THE MELL, *Solway, Southerness, Kirkcudbright, probably late nineteenth/early twentieth century*
Although the attribution of this photograph in the archive states that it was reproduced by Kissling
from a negative 'more than 50 years old', Kissling of course had all his pictures developed
professionally and, as far we know, did no actual developing himself. His ethnographic note reads:
'This ancient method of determining the position of the nets for fishing salmon in the Solway, prior to
the opening of the season, is still practised in some districts in a more or less modified form. Each
fisher (there may be a dozen or more) builds a small heap of sand upon the shore. One who is
selected to be the neutral man turns his back while the others stand at random beside the sand heaps
carefully noting each other's positions. The fishermen then stand aside. The neutral man who does
not know his own position, nor that of any others, kicks down one of the sand heaps. This gives the
man whose heap it was the first choice of place at the fishing ground, the positions of the others
depending on the order in which the sand heaps are kicked over.'
 The photograph was taken after the 'kick' apparently.

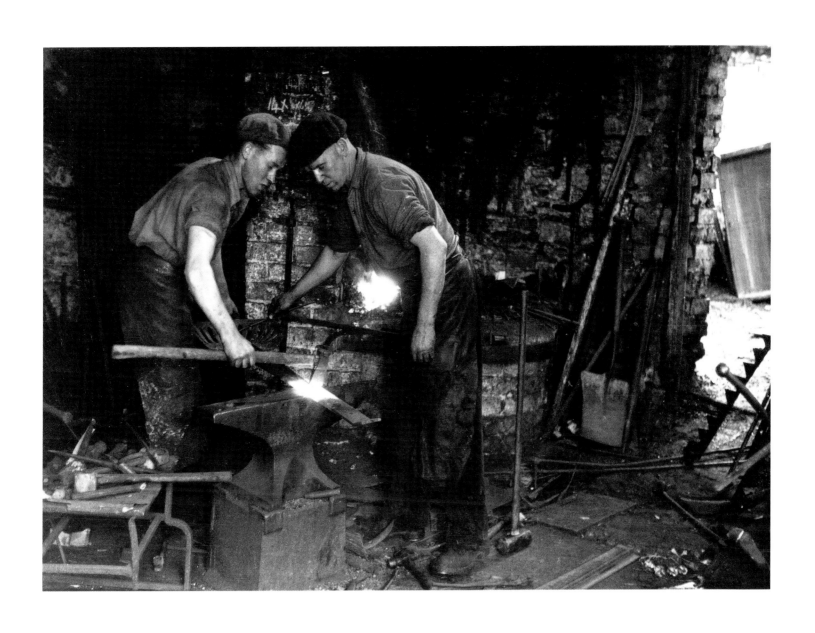

SMITHY, *Garlieston, Wigtownshire, 1957*
Preparing to break an iron bar with a sledge hammer.

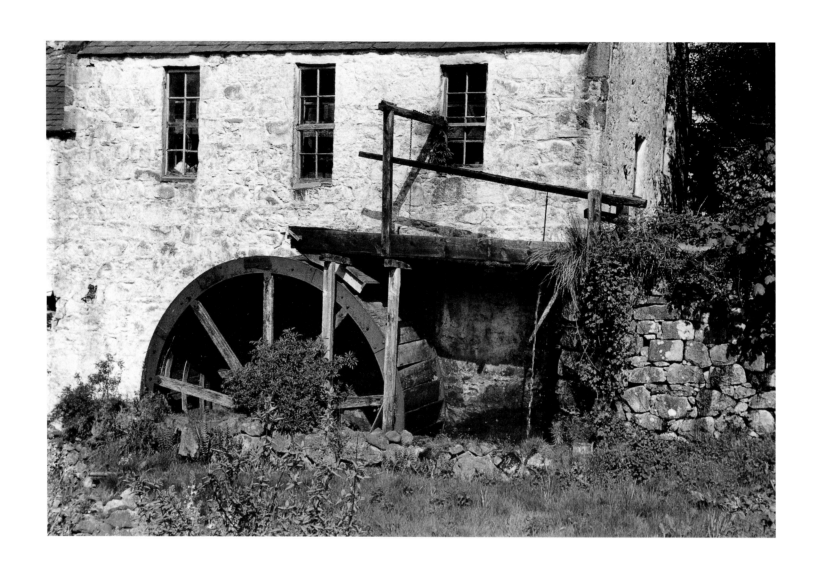

WATERMILL, *Newabbey, Kirkcudbrightshire, 1957*

122 *A Different Country*

CLOSEBURN WATERMILL, *Dumfriesshire, 1957*

The purpose of this photograph is not entirely clear. It may have been provided to the Dumfries Museum initially to record a notable building in its last years of life, or it may simply be a study in light, shade and shapes.

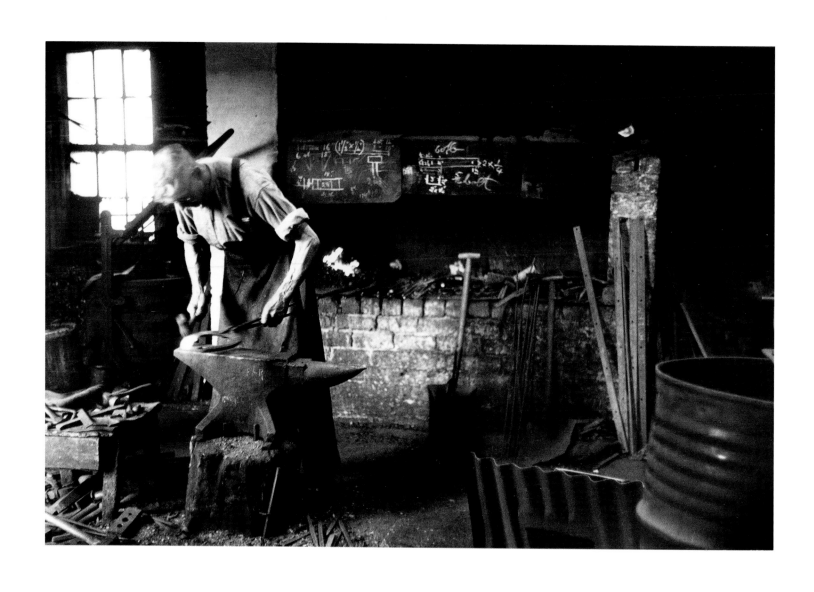

SMITHY, *Castle Douglas, Kirkcudbright, 1957*
The blacksmith, Mr John MacDonald, putting the clip on the toe of a shoe.

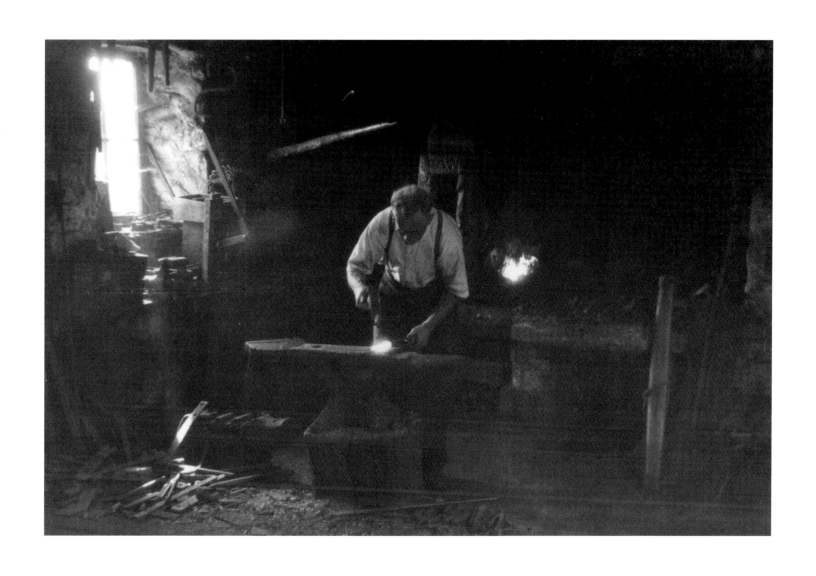

SMITHY, *Kirkland of Glencairn, Dumfriesshire, 1958*

LIGHTHOUSE, *Southerness, Dumfriesshire, 1958*
The overall impression of this photograph is overwhelmingly modern though its purpose may have
been to record the traditional stonework and the pinning of the balcony.

DRESSER, *Boretree Inn, Preston Mill, Kirkbean Parish, Kircudbrightshire, 1958*
Surprisingly like a much more recent photograph by Gus Wylie, this image seems to have caught
Kissling's eye, though again the bowls may be of a significance that we do not now appreciate.

USE OF CLEEK, *Roxburghshire, 1959*

These photographs are marked 'Not to be published' as they show an illegal activity – using a cleek (a barbed gaff) for poaching salmon. They have remained in the School of Scottish Studies archive since being contributed by Kissling and this is their first publication.

Kissling as an ethnologist would have been interested in the activity shown but sensitive about revealing who had demonstrated it for him. It was taken during his time at the King's Arms in Melrose, which might indicate that the salmon served at the hotel may not always have had a legal provenance.

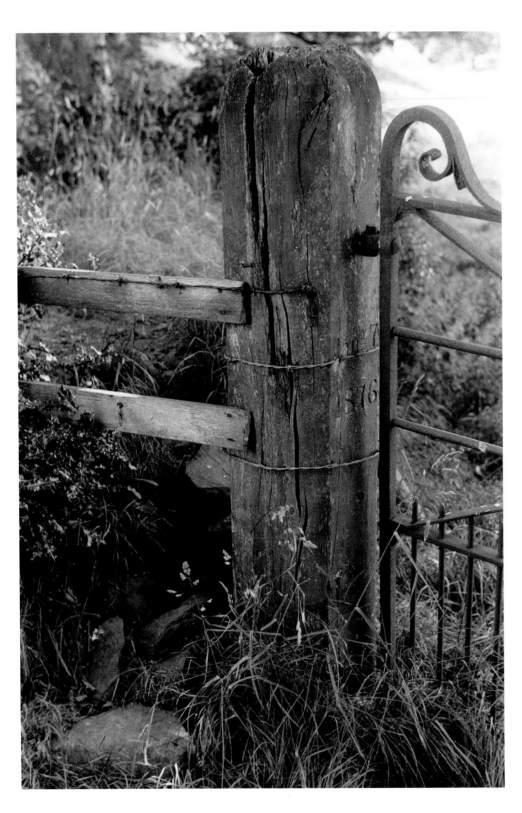

GATE POST, *Spottiswoode, Westruther, 1959*
The photograph is pin sharp and a wonderful example of Kissling's attention to detail and eye for the forgotten.

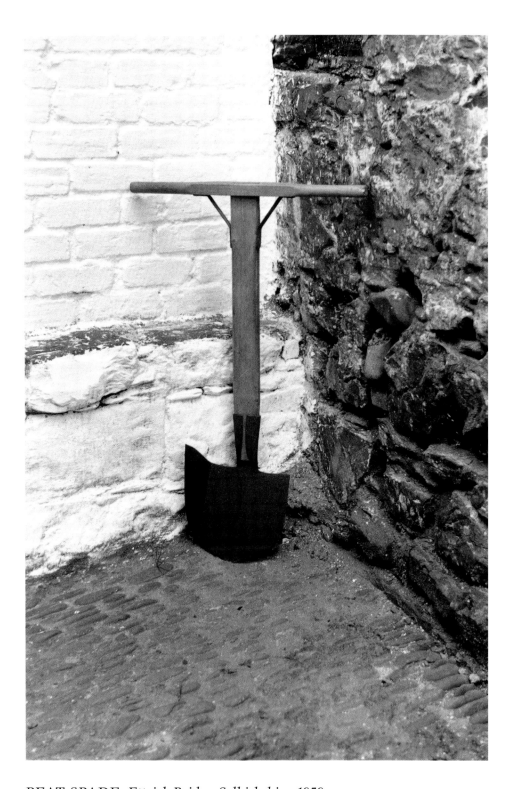

PEAT SPADE, *Ettrick Bridge, Selkirkshire, 1959*

Unlike other ethnologists, Kissling was not a frequent recorder of artefacts on their own. This photograph is therefore unusual. His note adds the detail, 'Side-wing at right angles for cutting peat into regular rectangular blocks. These spades are still being made by Mr Donald, Chapel Hall, near Airdrie, who sells them for £7. This particular spade was kept in the local Post Office.'

CLEEKS, *Roxburgh, 1960*
Two small cleek hooks, normally used for poaching. This is another atypical photograph showing artefacts without people. It may be a follow-up to the photographs of salmon poaching also taken in Roxburgh, though they are winter pictures.

THREE

Afterword

The Human Landscape

It is possible to view Kissling's photographs as merely artefacts of the past, chemically preserved fossils of a vanished time. As an ethnologist, Kissling tended sometimes to that view, wallowing in a sentimental attachment to disappearing ways of life and seeing himself as their final recorder.

But there is another possible view. Kissling's pictures can serve to remind us that there were – until very recently in historical terms – largely self-sustaining and self-reliant populations in the rural parts of Scotland. And they can encourage us to ask not just questions about the past, but questions also about the present and the future.

In his book *Stone Voices* – subtitled *The Search for Scotland* – the journalist and thinker Neal Ascherson observes: 'In Scotland most communities are improvisations in strait circumstances.'

There could be few better descriptions of the community of the island of Eriskay, particularly during the time of Kissling's first visits. Even today this description is apt, not least if one drives to the island over the new causeway and then continues on to the new ferry harbour, where it is now possible to embark for the neighbouring island of Barra which sits alluringly to the south.

The road between the causeway and the pier is a helter-skelter, pitching and rolling along the edge of a hill with blind twists and seemingly impossible cambers. Below it lies the main village of the island, though the term 'village' implies an order that is largely absent. Houses have grown up in corners of fields or – when planned by the council – in stark blocks at right angles to the roughly discernable flow of the landscape.

Inevitably the visitor will ask, 'What do people do here?' and the answer is not easy to find. There is some remnant of crofting, though the *machair* land is rich in wild flowers and grasses, implying an absence of the otherwise ubiquitous omnivorous grazing sheep. There are fishing boats in the two harbours and there is a school and a church. The new ferry needs crew and the roads – such as they are – do require mending. There is even, unusually for such a small island, a pub.

Unemployment in the Western Isles remains amongst the highest in Scotland. The

average age of the population is also high and the melding of those two statistics gives an indication of the reality – lots of people don't do very much in the ordinary sense of going to work for someone else. They may do some work for themselves if they rent (or more uncommonly own) a croft, and they may find casual work from time to time in a variety of occupations, from taxi-driving to casual labour to delivering bottled gas.

The highest proportion of those employed work for the local authority in jobs ranging from teaching to caring for the elderly. The bulk of other employers in the Hebrides are based in Stornoway, though they may operate up and down the long chain of islands – for example, in importing and distributing goods from the mainland. The two largest non-local-authority employers in Uist are the biggest local building firm and the now civilianised military rocket-testing range.

It is said that at the end of the Second World War the government of Norway asked the British government for advice on how to develop their offshore islands. The British government advised them not to bother, but to settle the small populations elsewhere, citing the example of the evacuation of St Kilda, which had taken place in 1930. Other islands had also lost their populations during the twentieth century in less organised and newsworthy ways – Mingulay, Scarp, Taransay and Boreray, to name but four, though Taransay returned to the headlines recently as the base for the BBC *Castaway* series, a paradigm for thoughtless sensationalism allied with arrogant cultural exploitation.

In Ireland island evacuation was even more dramatic. For example, the Blasket Islands, which lie just off the coast of Kerry, were finally evacuated in 1953, when the population of the last inhabited island, the Great Blasket, had fallen to only twenty. Yet only fifty years earlier that island had sustained a community almost eight times that size, and a community moreover which was contributing a library of literature to the world. Others went more silently, although the Aran islands resisted and now have a flourishing tourist trade

Fortunately the Norwegians did not take the advice offered to them. But equally significantly the British did not follow their own prescription either: Berneray, Vatersay, Scalpay and Eriskay all suffered continuing population decline during the 1950s, 60s and 70s but somehow the population stabilised. A lack of employment opportunities elsewhere was a factor; so was the creation of a single tier of local government for the Western Isles in 1974 and the determination of a new generation of islanders to try and maintain what they had inherited.

Transport was a crucial element in securing survival. If people could come and go – for school, for hospital appointments, for visiting, for simple shopping – then they were more likely to remain where they were. Berneray, Eriskay and Vatersay now have causeways, and Scalpay has a bridge. You can come on and off the islands whenever you like. Some people are beginning to move back, secure in the guarantee that they can go on working on the mainland of Uist or Harris without the fear of daily dislocation.

Yet that is a minor factor compared to the larger picture. The overall population of the Western Isles continues to decline. Lewis in particular is suffering a surge in depopulation that is taking away young families, usually in search of work, but also in search of readier access to the facilities and services to which they claim – however diffidently – a legitimate right in their role as modern citizens of a modern nation.

This problem has a curious and distant echo in the fate of St Kilda. St Kilda was not evacuated because it was too far away; it was evacuated because it became too close. The people of St Kilda became dependent on the visits of cruise ships and on the support of supply boats. Their disruption by weather caused hardship which previous generations accepted and expected but life on the island came to be seen as insupportable, even positively dangerous. To an extent the same issue resulted in the death of the Blasket Islands, though in that case it was exacerbated by the bitter experience of constant loss.

Rural depopulation – not unlike that which affects the islands – is a growing problem for most of our country. Admittedly it is not a unique, nor is it a particularly recent phenomenon, but its intensity in modern Scotland is sometimes breathtaking. It can seem as if anywhere outside an hour's commuting distance from a city is now at risk. Yet within that travelling time, there is a boom in new housebuilding.

Although we can visit rural and island Scotland very easily, not many of us choose to make the decision to live there. Most city and central-belt dwellers in Scotland are only one or two generations removed from their roots elsewhere, but this is time enough for the links of relationship and knowledge to have been broken. With something over eighty per cent of Scots now living in the central belt and its two spurs – down the Ayrshire coast and up the east to Aberdeen – the vast majority of us are now urbanised or suburbanised. We are not in any sense still of the land or dependent upon it. To take Ascherson's thought a step further, we no longer live as improvisers in strait circumstances.

The world of Werner Kissling – or even Paul Strand or Gus Wylie – is therefore not our world any longer. The majority, if they feel anything at all, feel an attachment to it through sentiment and nostalgia. As a result they are – however unknowingly – in danger of allowing the human component to be removed from much of our country and thus of abandoning it to nature.

Of course, some regard this as a good thing. Modern conservationists have persuaded us that the preferred state of our rural landscape is one in which human beings do not interfere and where the signs of human involvement with the land are absent, or have been eliminated. Despite the fact that historically almost all our landscape bears the imprint of human beings (from the destruction of the Caledonian forest to the effects of the introduction of the domestic sheep), we have been persuaded in recent generations that we should aspire – at whatever cost – to the restoration of some mythically pure and untainted environment, where every prospect pleases and only man is vile.

Some might take the same message from Kissling's photographs and from his only film, *A Poem of Remote Lives*, but that would be to misread them. Kissling's central concern was with how individuals worked and lived within a society, and his work did not dwell on the pristine or untouched parts of the beautiful landscape that surrounded them. Landscapes without people and people without work are rare items in his oeuvre.

In that sense his work is – though not as great in photographic terms – at one with the work in the Western Isles (as well as elsewhere) of Paul Strand.[1]

Certainly no one would disagree with the basic premise that man's intervention in nature has had some – sometimes vastly – destructive consequences. In some places in the world these are sufficiently chronic to justify the belief that only by returning to a much more responsible and responsive view of the interaction between man and nature can life in all its myriad forms be saved. And whilst in Scotland such places are not greatly in evidence – though the nineteenth-century scars of industrialisation still blight parts of Lanarkshire and Ayrshire – there are still lesser impositions that distort and damage the landscape and those who live in it.

In addition, as Scotland is not immune from larger and wider forces at work in the world, the overall impact of humankind on the planet has had consequences for Scotland's environment – the decline of the capercaillie because of warmer temperatures worldwide as well as changed patterns of hill use in Scotland is a case in point.

Nonetheless, there is a growing concern that this move towards a dehumanised Scottish landscape (a trend that has a political as well as an ecological foundation) is a trend that should be resisted, even though we must acknowledge the need for shared and individual action in protecting the environment from thoughtless and inadvertent damage.

The politics of rural versus urban Scotland are particularly worrying. The establishment of the Scottish Parliament was an opportunity to create a new vision of what Scotland is and what it could be. The Welsh historian Gwyn Alf Williams memorably asked the question, 'When was Wales?' as a means of confronting the realities of a small nation that was constantly changing in response to outside pressures. If we ask ourselves the same question about Scotland, there is a tendency to imagine an ur-Scotland of the kailyard rather than the Scotland we have today. For a nationalist, however, the proper response is not in the past but in a future, in which Scotland can at last realise its potential rather than explain why it is unable to do so.

However, the economic and ecological trend of centralisation – the drift of population and jobs away from rural Scotland and the difficulties of making a living in and a livelihood out of rural Scotland (usually now the result of government policy or

1 I am indebted to Fraser MacDonald of Aberdeen University for pointing out that similarity and for the suggestion – confirmed he believes by local evidence – that Kissling met the Strands when they were all staying at Lochboisdale Hotel.

government indifference) – means that on present projections this new Scotland will be a place of large uninhabited tracts of land in the west, north and south, with growing environmental and economic problems in a more and more crowded central belt.

It will be a place where policy and practice – underpinned by legislation – are centred on the needs of the urban many whilst ignoring the plight of the rural few. After four centuries of pondering 'The Highland Problem', the answer coming from Scotland's political classes and business élites will be one which makes rural living either a matter of poverty or emigration, a process begun by their forebears two and a half centuries ago. We will, in a more civilised but equally devastating fashion, finish the task started by the clearing landlords, both Highland and Lowland.

Representing as I do a very large tract of sparsely populated rural Scotland as well as the lower reaches of the central belt, I am constantly confronted with the feeling of alienated worry that exists just under the surface in all rural communities. The wide ranging and passionate debate that arose over the Wild Mammals Bill was a symptom of that syndrome, for it seemed to many inhabitants of rural Scotland – including the majority who had never hunted a fox and never would – that Scotland's new Parliament was legislating without thought for those who lived outside the cities and who confronted different day-to-day realities. Such a view is compounded by other decisions or nondecisions of Parliament and government: for example the appalling transport infrastructure in the Scottish Borders has been the result of generations of neglect, yet after three years of our new dispensation – and at least two parliamentary debates on it – the long awaited Borders railway is still not even on the official drawing-board. And those who travel on one of the main arteries between Northern Ireland and Europe – the A75 from Stranraer – do so at risk of their lives as road developments have not kept pace with the demands of modern traffic. The investment in the equivalent link from Holyhead is now putting at risk the entire future of the main port of south-west Scotland and all the jobs that depend on it.

The same concerns arise in different but even more immediately harmful ways in the Western Isles. The cost of transport and the difficulties in bringing the state ferry company, Caledonian MacBrayne, into the European administrative structures of the twenty-first century are constant topics of discussion, and that discussion is usually either predicated by, or ends up with, a complaint against those who live in the centre and who do not understand what it is to live elsewhere. The fact that the matters complained of are symptoms and not prime causes does not matter. Symptoms are enough to diagnose the illness, and the illness is one of neglect and indifference.

Yet where there is engagement that can sometimes be worse. That is particularly true when rural dwellers are confronted with the power of national conservation bodies and their insistence on imposing conditions and changes that may adversely affect traditional ways of life or contemporary ways of earning a living. From geese on Islay to rabbits on Barra, and taking in corncrakes in Uist and sea fish in

Shetland, the solutions demanded by conservationists often run directly counter to the needs of the communities which have found themselves surprised by the importance that outsiders attach to one single aspect of their daily lives. Those solutions are usually devised without any knowledge of day-to-day conditions and necessities, and the power of such bodies to make their writ run without the need to listen to or even acknowledge local opinion also comes as a shock.

For those unlucky enough to be involved at a local level – to be on the wrong side of these bodies – what they experience runs counter to any understanding they have of democracy. Little by little they come to believe – with considerable justification – that the key issue in rural Scotland is not the environment but the absence of normal democratic rights, let alone ways to exercise them.

The writer Ian Mitchell – who himself lives on Islay – has exposed in his book *The Isles of the West* the extraordinary powers of organisations such as the RSPB and Scottish Natural Heritage and the way in which such powers are exercised in an arbitrary and arrogant fashion. He has also illustrated the shallow thinking and lack of imagination of such bodies – most memorably in his revelation that the real threat to the corncrake comes not from Western Isles crofters but from Egyptian quail netters who annually slaughter thousands of the birds before they get anywhere near the Hebrides.

Mitchell has gone further and embarked on a voyage of discovery to examine how such problems are dealt with elsewhere. His next contribution to the debate – a new book entitled *Isles of the North* – will be an important element in helping Scotland's rural communities to fight back against outside imposition, whilst also reasserting their claim to be the real conservationists as they seek means of continued human presence in rural Scotland which can at once sustain and help the current environment.

Crofting in northern and western Scotland is a uniquely successful means of keeping people on the land, and caring for it, while accepting that the land cannot provide all the requirements and benefits of modern life. But the amount of land under crofting use diminishes year on year, with township after township losing families or children to the mainland and the cities, even if there is a small flow the other way as some seek to get out of the rat race.

Tourism, as a subsidiary industry, is one that can help to provide additional income to crofters, despite the vagaries of the Scottish weather. Yet here again centralising forces are at work. The high cost of petrol and the inevitable concentration of tourist attractions and facilities (and particularly state-supported national facilities) within the cities means that it is only the more adventurous and the more affluent that make it off the beaten track. In addition, the financial support available for heritage investment in rural Scotland is minuscule. The resource that can be applied to landscape interpretation and the provision of associated facilities is similarly constrained by policy, poor administration and lack of funds.

One of the most impressive museums in Scotland can be found at Kilmartin in Argyll. The contents of the exhibition rooms are interesting enough, if comparatively modest as collections go. The café and shop are welcoming and worth visiting. But what makes the museum special is the holistic view of culture and place that it presents. Kilmartin is at the heart of one of the longest continually inhabited parts of our nation and the surrounding landscape is full of signs of that occupation – cup and ring marks, cairns and rock drawings to name but a few. This landscape has became part of what the museum seeks to explain, as have the people who lived in it. Equally importantly, the museum trust sees its job as helping to preserve the landscape, whilst encouraging the development of a vibrant and sustainable local economy.

All this was the vision of the museum's founder, David Clough, who inevitably spent much of his period in charge deep in dispute with the Argyll and Bute Council, with the Scottish Museum Authorities and other grant-giving bodies, and with the Scottish Executive. None the less, he managed to sustain the operation – often on less than a shoestring – and win a clutch of national and international awards. And he attracted visitors by the bus and car load!

David Clough's vision of people, landscape and heritage as part of a single cultural continuum and his efforts to sustain a modern population in balance with each of the other parts of that continuum comprise is a noble ambition. But it is a rare one in modern Scotland. It is also very hard to maintain, given the fragmented nature of the organisations which deal with all these aspects of what the French would call our *patrimonie*.

For a start, the built and archaeological heritage is over managed but under resourced by Historic Scotland, which is the least flexible and most unaccountable of all Scotland's executive agencies. Other bodies involved include the National Museum and charities, such as the powerful National Trust for Scotland.

The environment comes under a ministry along with a clutch of other agencies and non-departmental public bodies, including the Scottish Environmental Protection Agency, Scottish Natural Heritage and a number of charities.

Culture, in its wider sense, belongs in a different category and is controlled by the state-supported National Cultural Strategy, an Arts Council, the National Galleries and even the National Library.

Bring in agriculture, planning and land use and there are even more irons in the fire, including those wielded by local authorities, by the Scottish Executive Agriculture and Fisheries Department and by landlords, including the State.

This clamjamphrie of officialdom makes the work of someone like David Clough a nightmare to contemplate, let alone to support. But even on a simpler level – for example on the level of helping to argue for the rights of the population in areas of special scenic beauty or special scientific interest – the fragmented nature of the official support and management structure means that civil servants and employees of charities can and do wield frightening and seemingly total power. And above the

level of the day-to-day, the challenge of systematic planning and the development and implementation of co-ordinated policy is nearly impossible to meet, diverted as it is into the mire of inter-agency dispute or the swamp of multi-agency inertia.

Kissling himself had some of these problems even in the 1930s. His tireless advocacy of the islanders of Eriskay and his attempt to get them a fresh water supply took up much of his time and involved letters to a range of individuals, from county-council clerks to government ministers. But today his task would be even greater. Establishing a new water supply on Eriskay would need environmental assessments, debates about SSSIs, derogations from action plans devised by wildlife charities, planning permissions and many more tortuous twists and turns through bureaucracies in Stornoway, Edinburgh, London and Brussels. In a mirror image of the plot of *Rockets Galore* – the Barra resident Compton Mackenzie's less successful sequel to the Eriskay-inspired *Whisky Galore* – the finding of a unique pink seagull would probably lead not to salvation for the islanders, but to their ultimate evacuation.

Bringing together landscape, environment, heritage and people to create a new dynamic for rural Scotland is the aim of people like Ian Mitchell and David Clough. Their arguments are based on the need to ensure that depopulation is halted and enough practical assistance provided to ensure sustainability within those parts of Scotland that are, so to speak, more than twenty minutes from a coin-operated laundrette. Ian Mitchell goes further, believing as he does that all areas of Scotland should have roughly equivalent rules and infrastructure. Then he suggests that individuals should be entirely free to vote with their feet, and live where they choose. If they leave the islands or rural Scotland at least they will be doing so by choice, rather than because of necessity.

The photographs of Werner Kissling remind us that there was a time, even as recent as the last century, when landscape, environment, heritage and people did co-exist. But because there was no political will to sustain it, or because there was no knowledge of how widespread the effects of its destruction would be, this delicate balance virtually perished. Now we have to find new and imaginative ways of rebuilding it.

At one time Kissling put his faith in enlightened outside interference – in the donation, for example, of the profits from his film première to the building of a road or in his badgering of officialdom to fund basic facilities. Those facilities have come but the overall situation has worsened. In Eriskay itself a new causeway may have stopped the outward drift, but in the islands as a whole – as in the rest of the Highlands and as in the Borders – the sense of alienation is more acute and the outside pressures on the population have increased. Worse still, through a combination of the proliferation of the mass media and demographic shifts, assisted by easier transport and a consumer society, people expect more and are therefore prone to a higher level of discontent when they do not receive what they see as their due, or when they have to pay more for it than their lower rural earnings allow.

What they possess culturally as part of our shared heritage is also under threat as our whole knowledge of who we are and where we come from is eroded and fragmented – and separated from the landscape that frames it and gives it context. The Gaelic language is the greatest casualty of this process.

How then do we resolve these problems and restore the balance of the human landscape that is Scotland?

The first step is to acknowledge the problem. The Scottish Parliament – and more accurately and importantly, the Scottish Executive – has got to think carefully about the effects of its actions.

Legislation must be considered not just for its power to enforce social inclusion or equal opportunities but also for its rural dimension. I continue to support radical changes in land ownership but these must put power and resources into the hands of people on the land, not just into the hands of more officials in Edinburgh.

Instead of creating new layers of bureaucracy we should instead accept that those who live on the land know best how to manage the land. Shared power for rural and land management should arise from shared residence not from the privileges of outside control or distant ownership. A new partnership between large and small owners, tenants and those who have no stake except the responsibility for their families and their futures would create a new dynamic in much of rural Scotland and – in time – remove the distant echoes of oppression and exploitation.

Accepting that, we might also then accept that maximum diversity in approaches to the environment is a good thing and that single fads or fashions run from the centre are usually transitory and usually wrong. For biodiversity to flourish, it is the individual approach, that needs to be encouraged.

We must also defragment the stewardship of our landscape. A bonfire of the quangos could blaze happily for months if it was fuelled with a stack of environmental, heritage and agricultural bodies. In their place would be a much smaller and more efficient structure (with suitable outside checks and balances) that ranged over all these issues and was democratically constituted and controlled. Most importantly, it should have no power to operate without the express consent of those whose lives and livelihoods it sought to affect and it should also have means to take its policy direction from those same individuals and communities, not just from government.

In Gaelic Scotland, investing in the language by restoring language rights, encouraging its use in official and economic circumstances and increasing funding for Gaelic education would be vital steps, for the links between language security and growth and economic development have been proven in many parts of the world.

Understanding the environment as being the sum of many places not a single concept would also help. So would a determination to resist the imposition of a new regime of green lairds who – through their official bodies – often seem intent merely on taking over where the old tartan and heather variety left off. Sterilising the land by removing the human element from huge areas was, after all, their objective too.

Helping the young to stay in their communities with the provision of affordable housing (by supporting the development of appropriate modern house design and building, as exemplified in work done on modern versions of the black house), allied to meaningful work, and encouraging incoming residents by means of better telecommunications and local facilities, are fundamental parts of an essential strategy.

Above all refusing to accept the inevitability of rural decline and urban growth in Scotland and refusing to go along unthinkingly with the tide of globalisation unless it has benefits for every section of Scottish society must be priorities for government.

The late Sir Robert Grieve (probably the finest strategic planner that Scotland produced in the second half of the twentieth century) once privately remarked that he might be a nationalist someday, but only if Scotland had managed to solve its two outstanding physical problems: those of Glasgow and the Highlands.

Glasgow's problems remain difficult but solutions are being proposed. The problem of the Highlands, on the other hand, does not arise from lack of ambition or lack of appropriate skills but from oppressive and occasionally destructive local and national administration working to an agenda which neither supports nor suits the needs of the area. To solve the Highland problem we need much more devolution of power to those who live within the Highlands. We need to inject democracy into decisions on the land and on the economic and social future of those who live there. And we need to accept that distant government hardly ever knows best.

The problems of rural Scotland, like those of Glasgow, remain to be solved. Yet there are means of solving them and in solving them we can, as Sir Robert Grieve saw, provide the foundations on which we can build something new for the whole country.

The poet Iain Crichton Smith, in a brilliant essay called 'Real People in a Real Place', written in 1982 but first published only in 1986, examined the issue of culture, language and community through the eyes of an islander. In the essay he identified some of the elements of distance that lie within the minds for all those who leave rural Scotland, or who remain there but feel separate from the mainstream of society. And he concluded with these words not only about the loss of language but also about the loss of place:

> They will have been colonised completely at the centre of the spirit, they will be dead, exiles, not abroad but in their own land, which will not reflect back the names they have given it. Such a people will be a race of shadows and in that final silence there will be no creativity. They will be superfluous talking without alternative in a language that is not their own.

A Scotland that allows its rural part to wither and die will be a Scotland peopled by a race of shadows. It will talk to the world in a language that is not its own and it will have lost the understanding of at least part of itself. It will pervert creativity and what is left will have nothing of the power which shines through the images recorded by Werner Kissling – and nothing of the hope either.